9/94 X

W9-APW-466

the card book

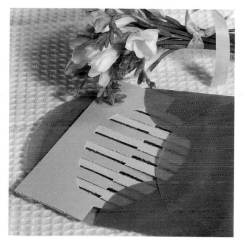

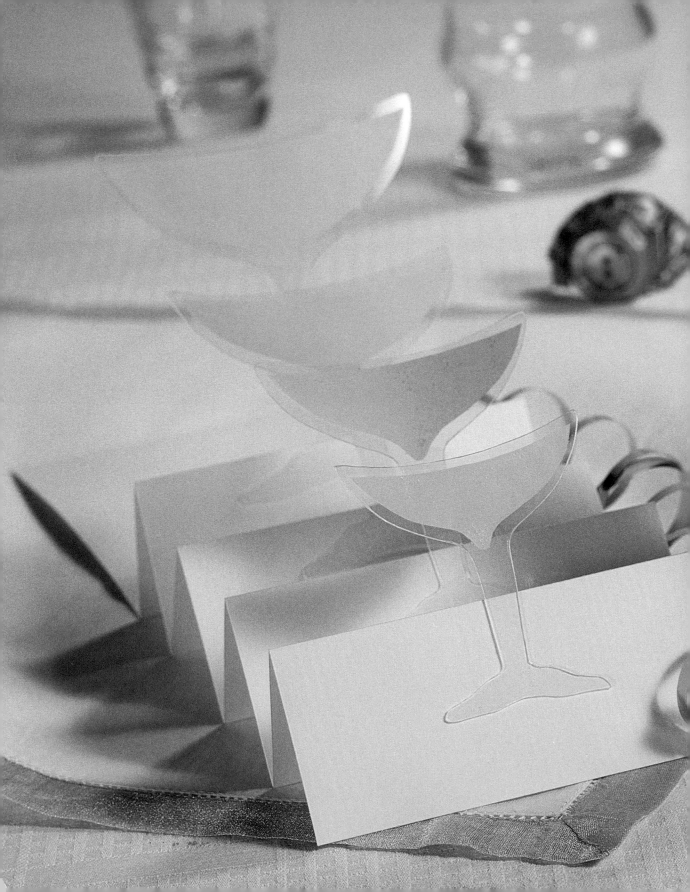

the card book

SUSAN ATTENBOROUGH

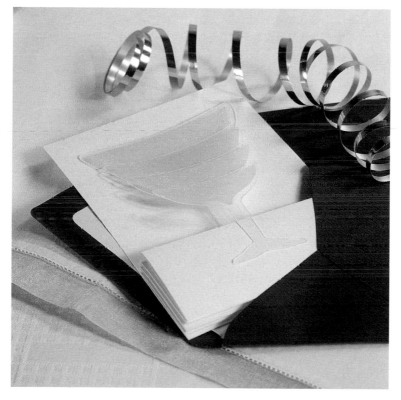

PHOTOGRAPHY BY ANNA HODGSON

A Dorling Kindersley book

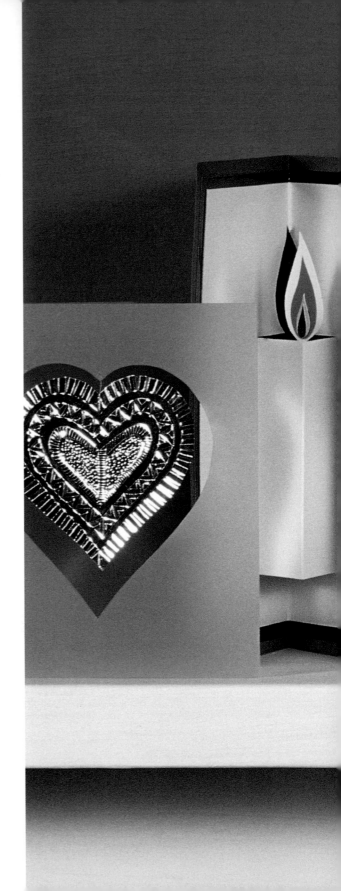

LONDON, NEW YORK, SYDNEY, DELHI,
PARIS, MUNICH, and JOHANNESBURG

Senior Editor **Heather Jones**
Senior Art Editor **Wendy Bartlet**
Designer **Louise Pudwell**
Category Publisher **Judith More**
U.S. Editor **Barbara Berger**
Art Director **Janis Utton**
Production Manager **Sarah Coltman**
DTP Designer **Sonia Charbonnier**

First American Edition, 2001

00 01 02 03 04 05 10 9 8 7 6 5 4 3 2 1

First published in the United States in 2001 by
DK Publishing, Inc., 95 Madison Avenue
New York, NY 10016

DK Publishing offers special discounts for bulk
purchases for sales promotions or premiums. Specific,
large-quantity needs can be met with special editions,
including personalized covers, excerpts of existing
guides, and corporate imprints. For more information,
contact Special Markets Department,
DK Publishing, Inc., 95 Madison Avenue,
New York, NY 10016 Fax: 800-600-9098.

A catalog record for this book is available
from the Library of Congress

ISBN 0-7894-8020-4

Reproduced by Colourscan, Singapore
Printed and bound in Singapore
by Star Standard Industries

see our complete catalog at
www.dk.com

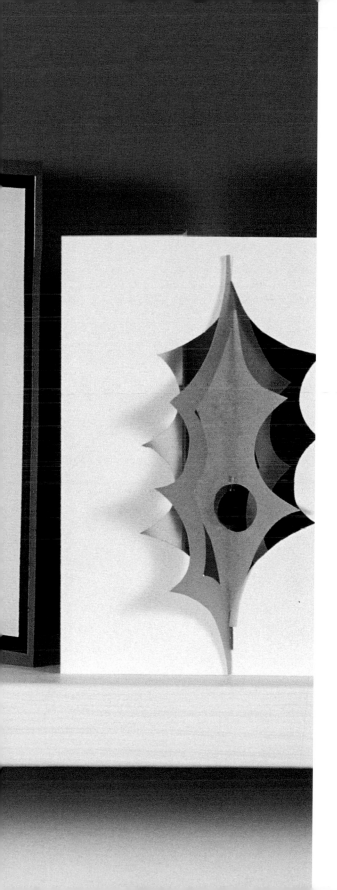

contents

introduction

Making your own cards is fun. It is also a very personal way to greet your friends. Somehow, once you have begun the tradition, it is very hard to buy a card: however beautifully made, no commercial purchase carries the individuality of your own work.

This book features 30 cards based around 12 different techniques, with several variations. Many of the crafts used could become a hobby in themselves and you can find whole books to tell you more about them.

Using specialist tools for some of the techniques will be easier or more effective, but you may not wish to make the investment for a few cards. Some basic equipment is essential for many of the designs. You may prefer to use scissors or a craft knife: it's often a matter of personal preference, but sometimes only one or the other will do. Whether knife or scissors, keep blades sharp, and use and store safely.

These designs rely heavily upon skilled choice of material. Color is a matter of taste, while texture and thickness will also affect the way your card cuts or folds, as well as the final look. Papers always seem thinner in a large sheet. Making cards in bulk takes time and needs to be carefully planned. When using a template for a run of cards, do not use your original. As the photocopy becomes degraded, you can make a new copy from the original.

Most important of all, treat the designs here as a springboard for your own originality. Pick and choose. Adapt ideas and colorways. Modify cards for different occasions. Explore and have fun.

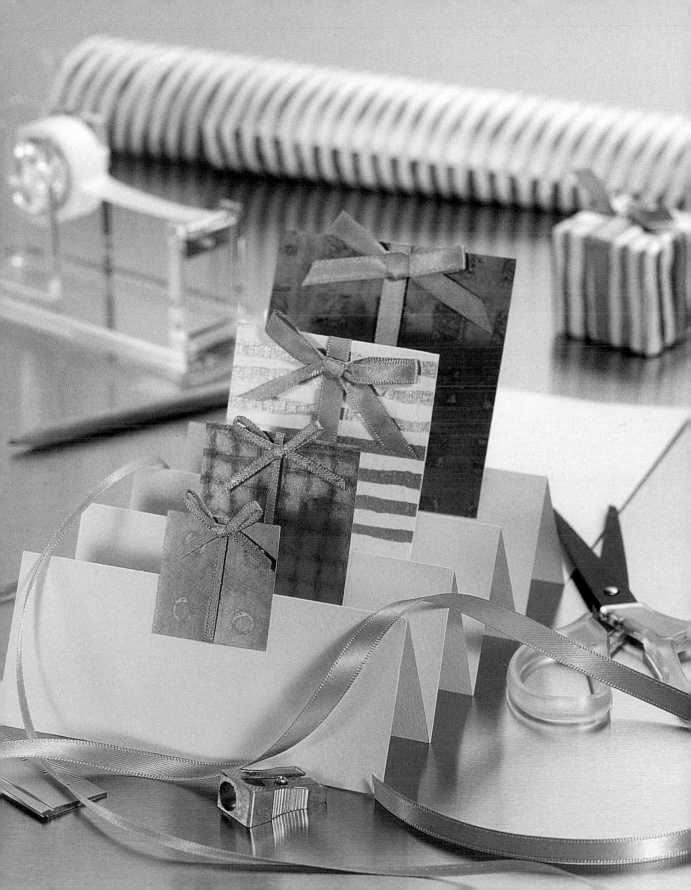

christmas

Christmas is a great time to send a handmade card to someone special – or to get a production line going and make dozens for all of your friends and family! You can be as contemporary as you like by reworking the traditional themes in unusual ways. Check out the Candle Card on page 26 in the Festivals section: the candle as a symbol of hope is equally applicable to the message of Christmas.

hologram bauble

This glitzy hanging card celebrates the sparkle of Christmas in style, and can look especially dramatic if set where light can catch it and make the colors in the hologrammed plastic flare into life. Such greetings double as decorations and will find a place on the tree, under a mantle, or even on a convenient hook. A hand-delivered card could even incorporate a tiny bauble or bell at its center.

Follow the instructions on pages 92–93, using the templates on page 107. Add your greeting by writing directly on the outermost ring of the bauble – a fine overhead transparency pen will work on a plasticized surface – or you could hang an extra paper shape from the lowest point of the card for your message.

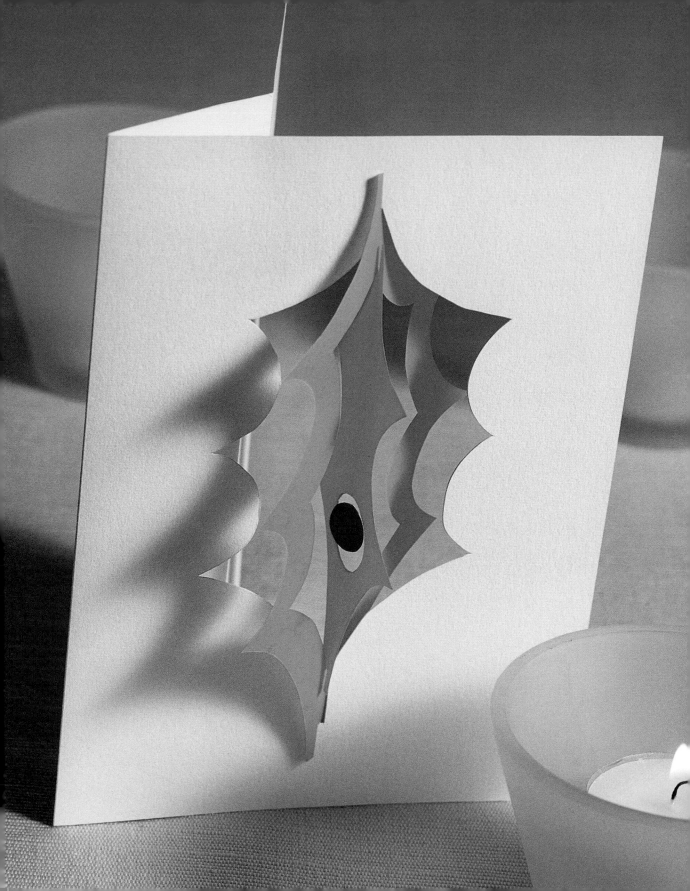

holly and berry

A familiar Christmas motif is given a cool, contemporary twist using stylized leaf forms and translucent, lime-green paper. When the card is opened, the spiky holly leaves spin independently on the same axis within a frame of ice-white card.

Use the templates on page 104 and the slot-in instructions on pages 88–89. The foil circles that form the center berry are small and light so the thread must be fine and flexible if the finished berry is to hang properly. You can use the holly leaves to make free-hanging decorations for the Christmas tree or mantelpiece too. Simply omit the slots, and taper the top of template B. Punch a hole at one end for a fine ribbon or thread loop.

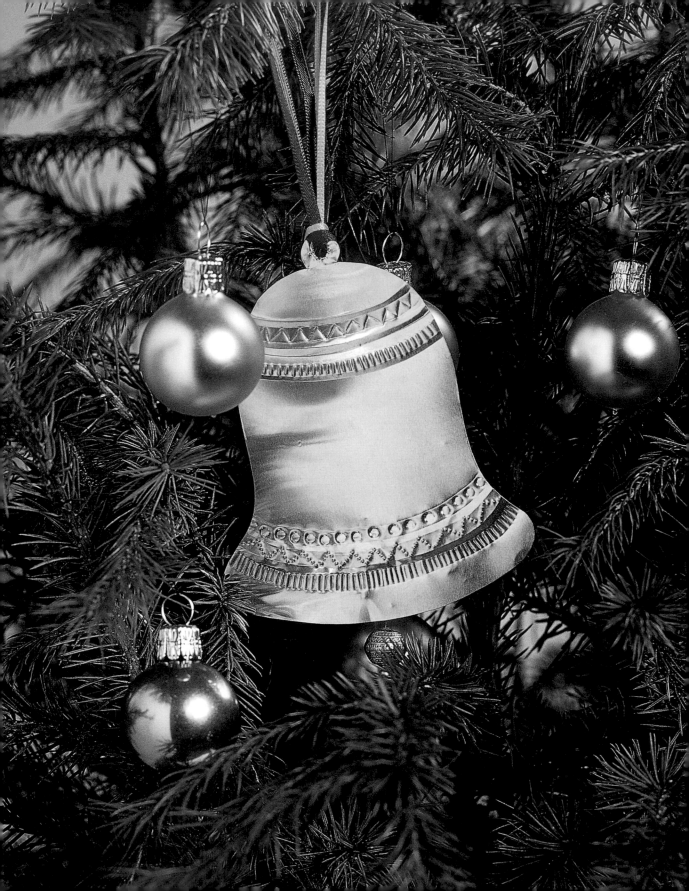

golden bell

A traditional motif, crafted from metal foil, is trimmed with an array of very fine, satiny ribbons that act as a softening contrast and enable the recipient to hang your greeting on their tree.

Adapt the instructions for embossing on pages 80–81, using one of the templates on page 106. Thread a toning bead on gold thread and tape unobtrusively to the back, so that it looks like the bell's clapper.

You can send the bell just as it is, or mount it on a card for presentation – make a cut at the center top of the front of a piece of folded card and push the loop of ribbon in. Alternatively, the bell can be treated as the Silver Fish on pages 34–35, mounted on some luxurious silk or fine velvet in rich jewel-like colors for a truly opulent effect.

twirling tree

A simple shape is turned into a sophisticated card mobile in dark green craft foam strips linked by silver-lined glass beads. The heavy base bead ensures that the tree hangs well, allowing the overall triangle shape to appear and disappear as the foam strips swing in and out of alignment.

Follow the cutting foam technique on pages 86–87 using the template on page 107. Write your greeting on a paper strip that matches the foam color and then stick it onto the lowest strip of foam with a glue stick or double-sided tape.

For a wintry effect, use white foam and dribble white glitter glue along the top of each piece, letting it occasionally trickle down the sides. Let the glue dry thoroughly before assembling the tree.

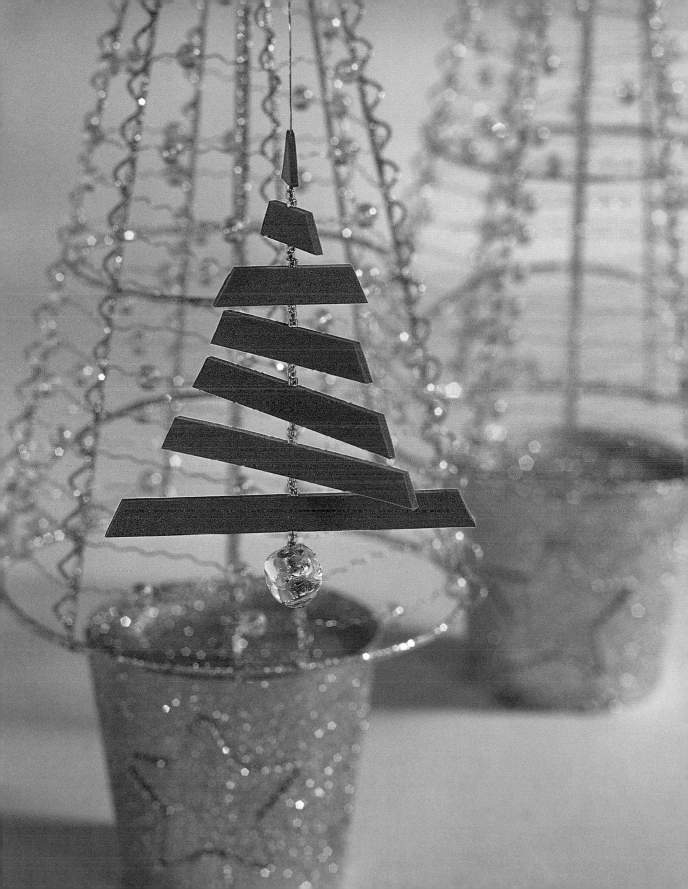

snow crystal

This elegant design reflects the six-pointed symmetry of an individual snow crystal, and is easily created with assorted quilled paper rolls glued onto a paper framework.

Follow the instructions on pages 98–99 and the underlay guide on page 106. Use cool colors, enhancing the white with touches of pastel blue, mauve, or silver-gray. To hang the crystal, thread decorative thread through the tip of one arm as shown on page 99. Hang a matching paper hexagon from the lowest arm in the same way for the greeting.

To make the design freestanding, glue the crystal onto card, as in the Rustic Sunflower on pages 68–69. The central star of the original design makes an effective gift tag glued onto a pale blue frosted card.

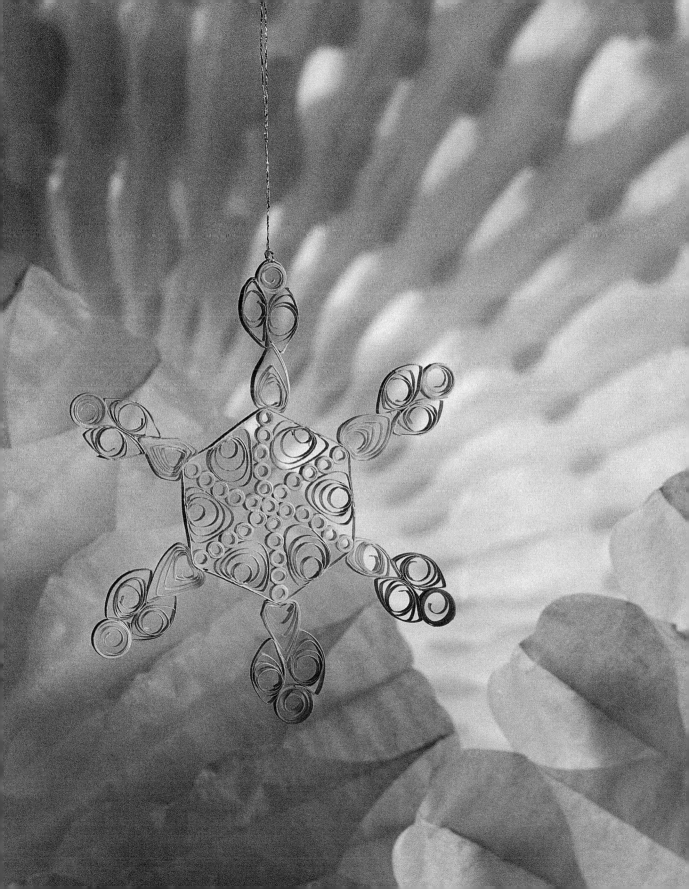

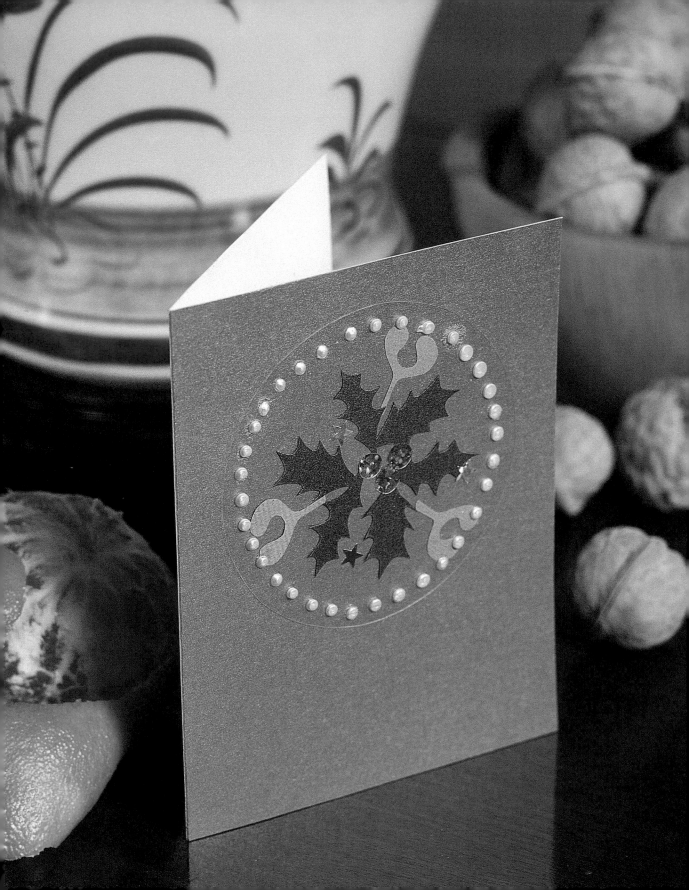

evergreen ring

An arrangement of tiny Christmas evergreen leaves and silvery sparkles looks suitably festive on a satin-gold card. The ring of pearly cream three-dimensional fabric paint dots is reminiscent of the mistletoe's berries.

The layering technique on pages 82–83 is simplified here to frame tiny holly and mistletoe sprigs, using the templates on page 106. Choose a thin, crisp paper as it is easiest to cut – a high laid type that has a textured surface will give a subtle self pattern.

Change the feel of the card by using other Christmas evergreens. A glossy green holly leaf with shiny red berries, perhaps entwined by ivy leaves, would lend a more traditional air. The card also works well as a tiny gift tag, or even as a motif applied to plain wrapping paper.

dancing snowmen

These merry snowmen are all individuals. Each is slightly different in shape, size, or detail, but all carry traditional Christmas candy canes to complement their dapper top-hat-and-tails image.

Use the templates on page 116 and follow the stand-ups technique on pages 100–101. To make the canes, twist together one silver- and one red-coated $\frac{1}{5}$in (5mm) copper wire; then bend the top end of the twisted wire around a pencil, to ensure an even curve to the hook. Hats and ties are fixed in place with double-sided tape.

Tiny silver stars pasted onto the "sky" form the only other ornamentation. This understated, whimsical card is enhanced by the textured white paper used for the stand-up itself and the outer card.

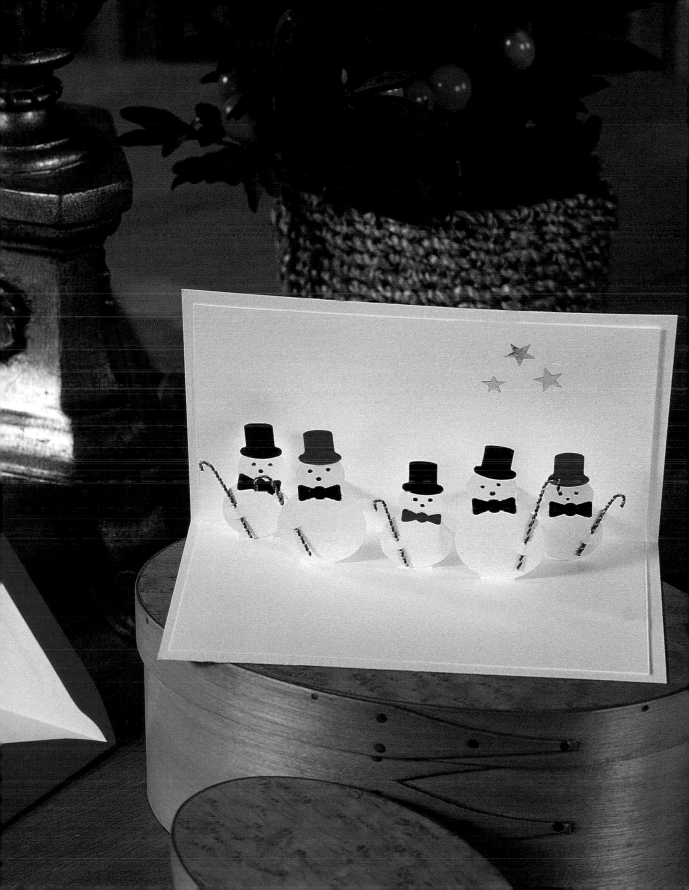

festivals

Today's multicultural society is reflected in a series of cards designed to celebrate festivals of faith from the Muslim and Jewish calendars, as well as the Christian festival of Easter and the African-American celebration of Kwanzaa. Making your own card is a very personal way to commemorate these special occasions. The universal theme of light is prevalent in many cultural and religious festivals.

candle glow

Light, especially candlelight, is one of the world's most enduring spiritual symbols. A candle carries a message of hope, of triumph over adversity, or simply of peace. This card would be appropriate to celebrate the festivals of Kwanzaa, Hanukkah, or Christmas.

It is made using the simple pop-up technique on pages 84–85 and the template on page 113. Use three papers with different textures: this example employs a matte lavender paper, a shiny purple metallic paper, and a lustrous pearly cream card. The colours of the flame repeat the colours of the card, but you may prefer more realistic hues. Substitute matte and shiny gold for the two outer papers and this card becomes a handsome way to mark a golden wedding anniversary.

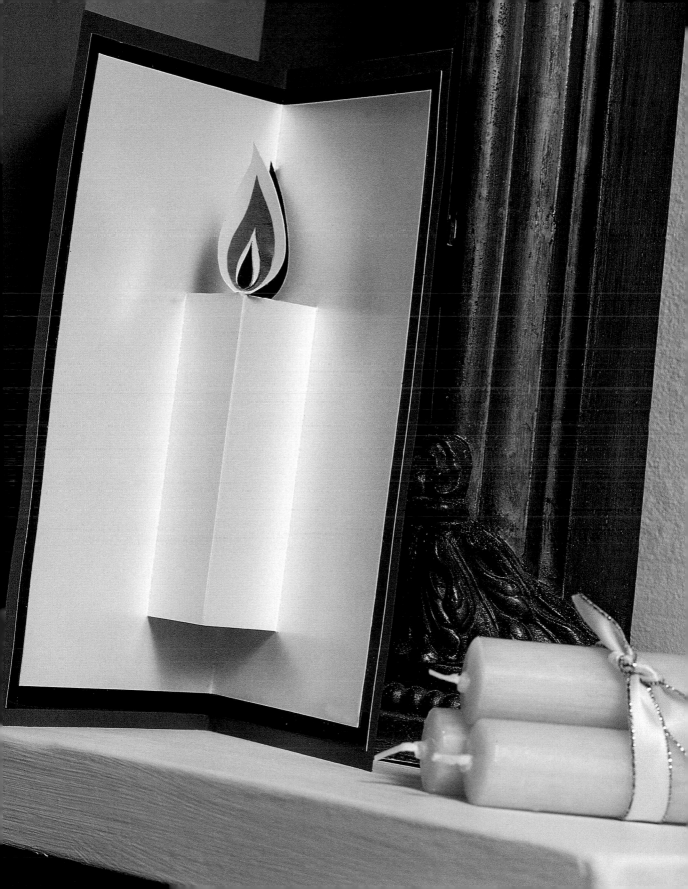

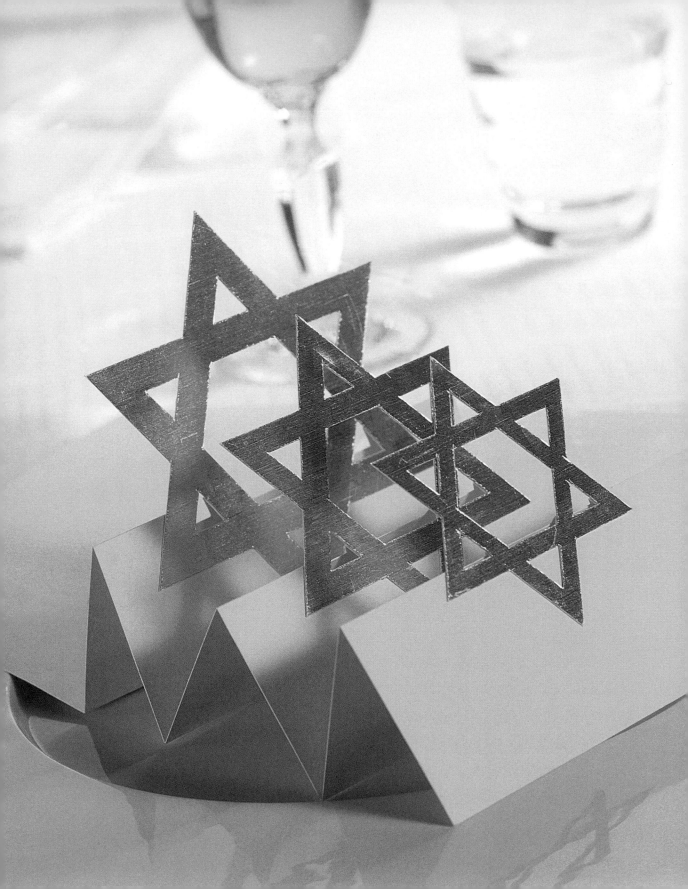

star of david

This is a perfect card to greet the Jewish New Year, as well as to celebrate other festivals within the Jewish calendar. The star's shape lends itself well to the repeating accordion design – the three golden stars form a pleasing pattern when the card is closed too. When the card is opened, the golden stars reflect each other if the paper is extra shiny.

Follow the accordion technique on pages 90–91 and the open star templates on page 108.

Make a special envelope for this card (see page 122), adding a simple border with gold ink as a finishing touch. The star is a versatile motif, and you could modify these open stars to send congratulations for success in examinations.

moon and stars

Particularly associated with the Muslim Eid festivals, both Eid al-Fitr and Eid al-Adha, a crescent moon and stars can be used in celebration of many events, in many faiths. Midnight-blue rings contrast with the gold symbols, and create striking shadows if appropriately hung.

Follow the spheres technique on pages 96–97 and the templates on page 109. For the stars, cutouts are highly effective, but be careful not to weaken the card by cutting too close to the edge of the rings. Place sticker stars in between the cutout stars, trimmed to size.

Vary the design by using silver motifs or only one style of star. To create a Christmas mood, the crescent moon could be replaced with a larger central star made out of satin or glossy metallic paper.

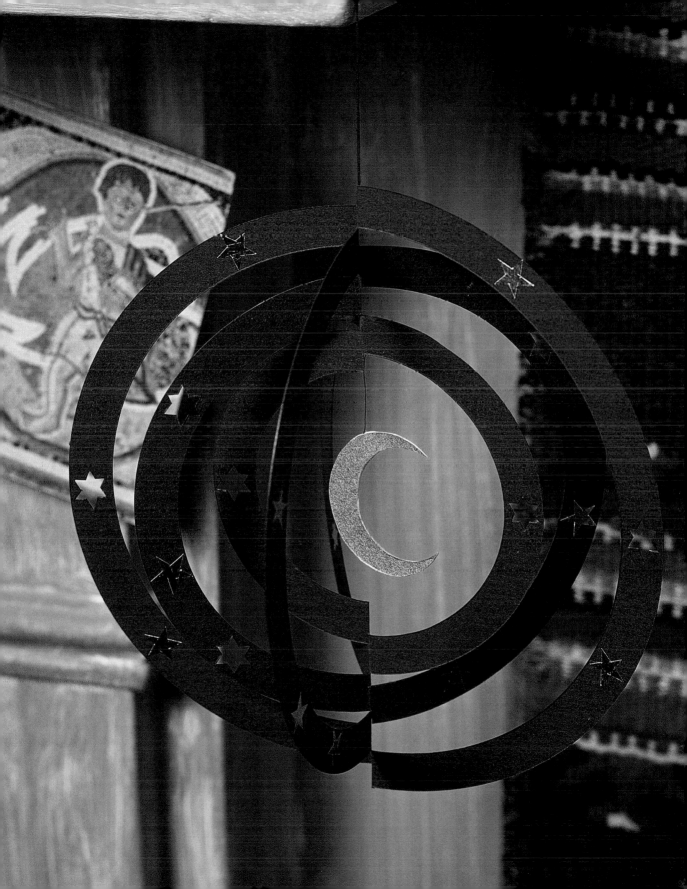

easter egg

Cheerful yellow two-tone paper lends a springtime air to this sleek and elegant Easter design, both when the card is folded and when it is open, while fine glitter adds a sophisticated sparkle.

The turnstiles technique on pages 94–95 works well with the simple egg shape template on page 110. You can make a two-tone card by gluing two pieces of colored paper evenly all over to stick together back to back if the ready-made sort is unavailable.

Once the card is cut, use a toothpick or thin brush to apply the finest line of PVA glue (woodworking adhesive) all around the outside edge of each outward-facing arm, then dip it in glitter powder. An acetate envelope makes an unusual presentation.

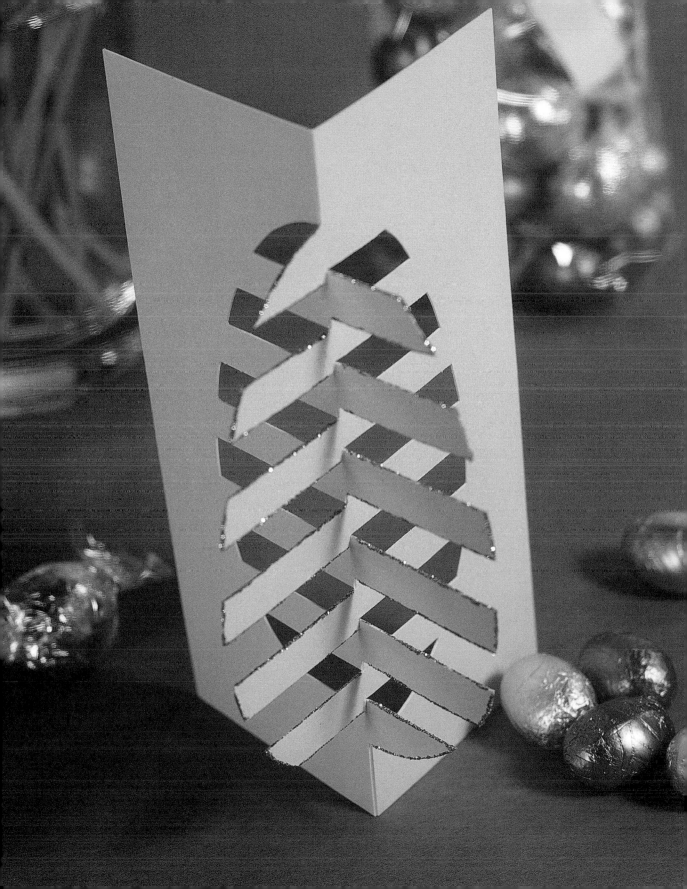

silver fish

The traditional Christian image of a fish adorns a multi-layered card that is suitable for many occasions, especially Easter; the fish is also associated with good fortune and the astrological sign of Pisces.

Adapt the foil embossing technique on pages 80–81 and use the fish template on page 110. Mark rows of tiny scales on alternate sides of the foil, then add fin pleats. Dab the foil with thixotropic gel paint, which allows the metallic glint to shine through. Once dry, use double-sided tape to mount the fish onto two different textured sheets of paper, then fix the construction to a folded piece of translucent turquoise plastic. Try using twisted silver wire to replace the foil fish; fix it in place with loops of wire pushed through the corrugated card. Finish with a silver bead eye.

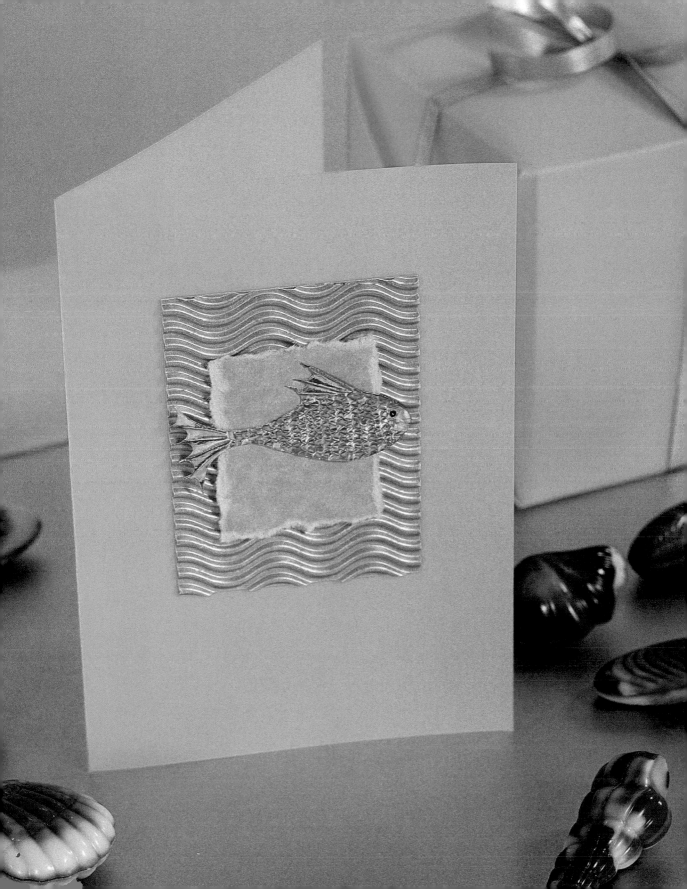

good luck

Any challenge — moving to a new home, passing a driving test or an exam, or taking a new job, leaving friends and colleagues behind — can be acknowledged and shared in a very special way with a handmade card. Some ideas here are particular to specific events, others will suit any number of occasions. All are a springboard for your own imagination.

farewell wishes

This is a useful design for a friend or colleague that is moving or retiring.

An old-fashioned fountain pen pops up and a glossy trail of "wet" ink

flows freely onto a piece of high-quality writing paper.

Follow the stand-ups technique on pages 100–101, and the

templates on page 111. Black craft foam gives the pen real thickness, but

thick paper would also work. The golden reflective card used for the

traditional nib is repeated in the double-sided framing layer, and the ink

squiggle is brushed on fabric paint. The paint is slow to dry, so allow

plenty of time for it to set before closing the card.

You could replace the abstract line with a farewell message or use a

modern pen shape and colors to bring the card more up-to-date.

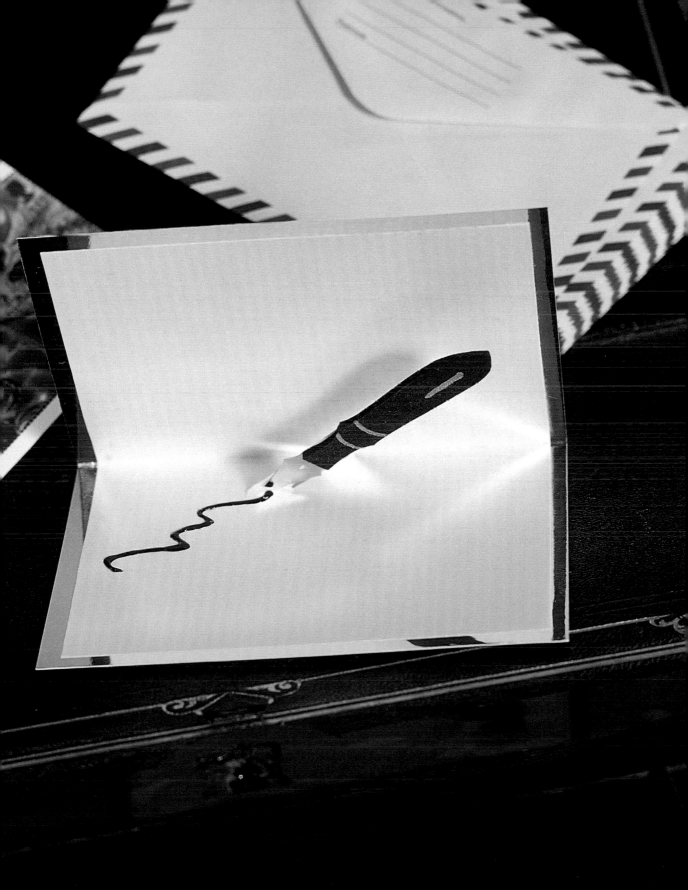

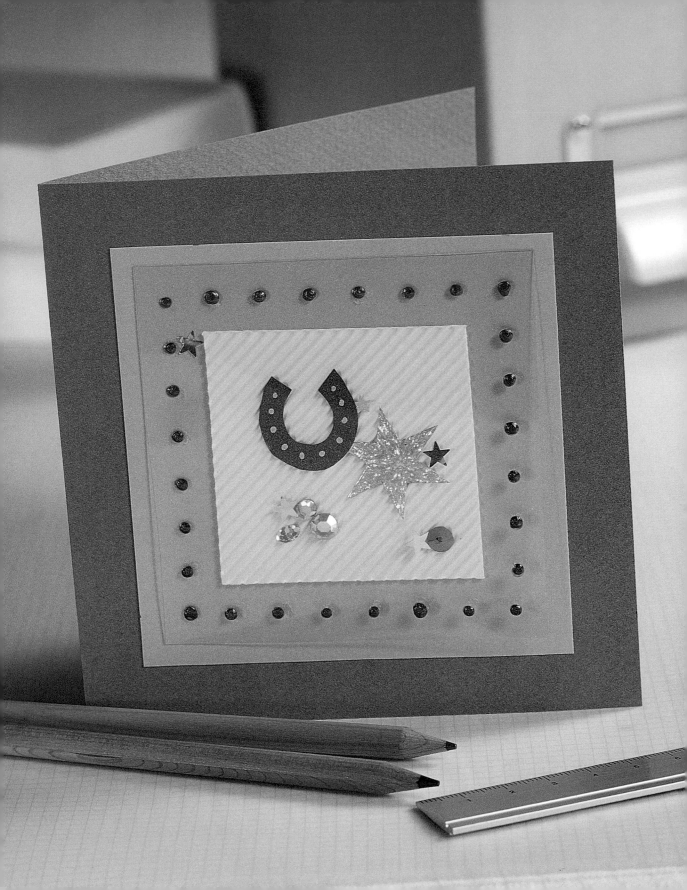

lucky horseshoe

This playful good-luck card features a horseshoe cut from a dark-gray pearly metallic paper, decorated with a silver pen, glued firmly upright, and complemented by sparkly, silvery shapes.

Follow the layering instructions on pages 82–83 and use the simple horseshoe template on page 111. Several different star paper shapes, rhinestones, sequins, and stickers are used to complete the mini composition behind the acetate.

To jazz things up, add further glitz with a metallic or shiny black card to complement the silver theme, or use vibrantly colored card for a bolder statement. You can adapt this design to suit specific events: tiny license plates for a driving test or boxes for a house move, for example.

four-leaf clover

This attractive card is a variation on the basic pop-up, although the more complex lines give it quite a different feeling from the simple pop-up on pages 26–27. Send it to someone to wish them a Happy St. Patrick's Day.

Adapt the simple pop-up technique on page 84–85, with the template on page 115. A green reflective-card mount sparkles against the subtly textured heavyweight rag paper used for the clover cut-out. You may like to back the reflective card with the same paper that you used for the clover cut-out to give a satisfying outer finish to your card.

Cut away the tiny decorative windows on each lobe of the clover as shown. Cut the stalk shape away too, and when fixing the two layers together, make sure that the edges of the stalk slit are glued down.

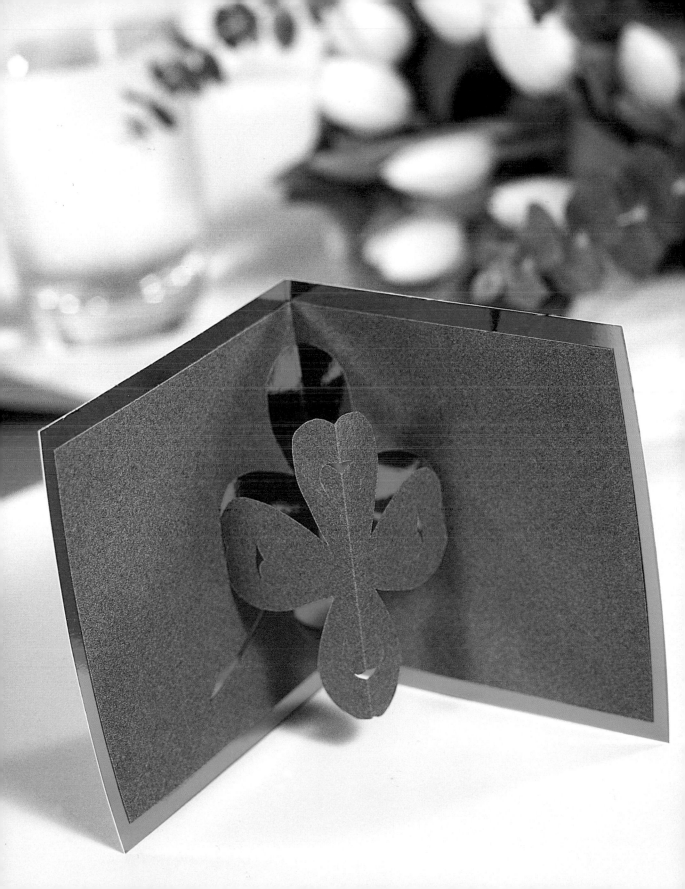

new home

Designed as a welcome to a new home, this card can be personalized by replacing the heart with a house number, family name, or other motif.

The design is a variation on the pendants technique on pages 92–93, with the outer shape cut into the front of a free-standing card. You will find all the templates on page 112. Two sheets of handmade copper-colored paper are glued back to back and the heart is cut from rough ivory paper and hung on plain cotton thread. Infinite variations suggest themselves: you can modify shape, color, and paper texture to relate more closely to the new home. Or, write the house number or family name in permanent marker on a piece of acetate, and sandwich it between the smallest house shape before gluing.

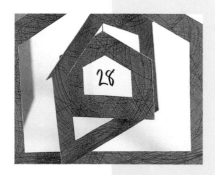

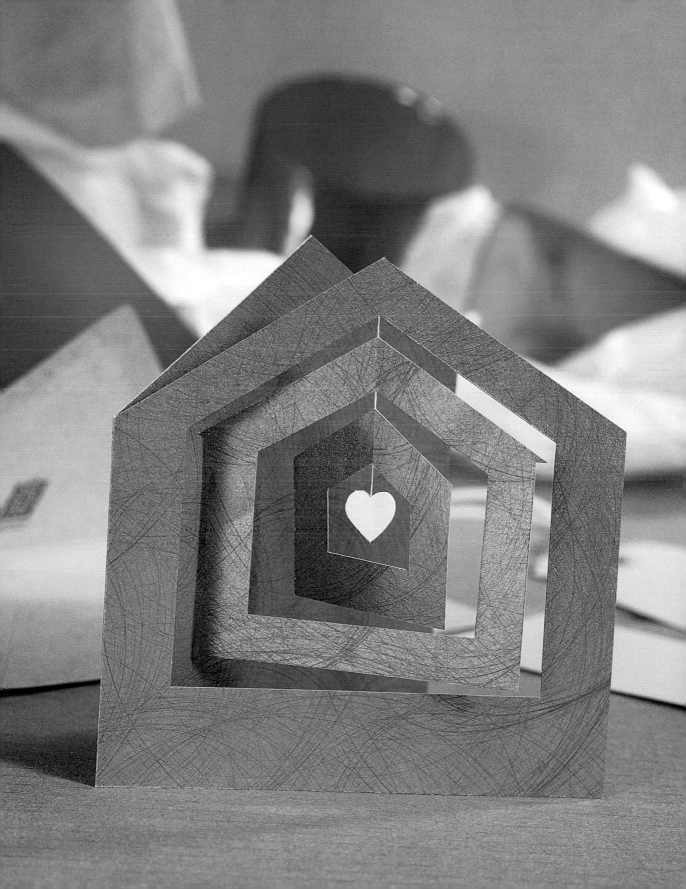

romance

Romantic rites of passage are the theme here, from the first tentative anonymous valentine card, through courtship, engagement, wedding, and anniversary to ideas for silver and golden wedding celebrations. Unusual materials in traditional and surprising colors provide several different ways to get that romantic message across — from the cooly sophisticated to the positively wacky.

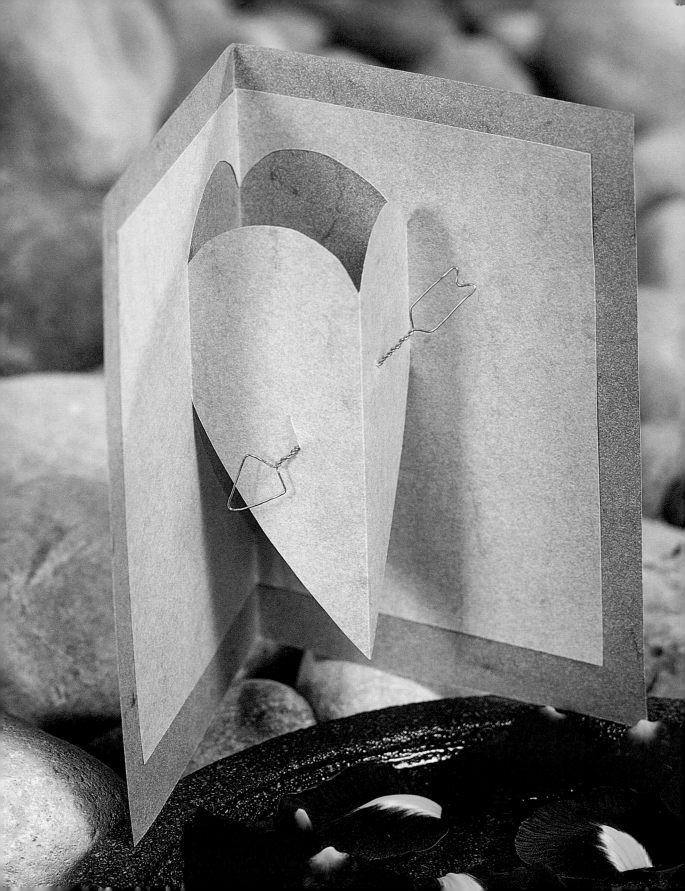

rock-solid heart

A monochrome greeting that reflects the idea of a love built to last, this card uses crisp, lightly veined elephant-hide papers in two shades of gray.

Follow the simple pop-up technique on pages 84–85, using the template on page 105. Form the copper wire arrow carefully following the template guide; conceal the ends in the twisted shaft. Ease the arrow through the marked slits, and close the card experimentally to check that it does not catch on the paper.

Brighter colors would work well too. Gold, silver, and color-coated copper wires are all available to team with papers of your choice. If you prefer a more emphatic arrow, wrap tiny scraps of embossing foil smoothly around the head and tail.

soft hearted

This subtle, ivory heart will appeal to the sophisticated romantic and makes a suitable card for Valentine's Day or a wedding anniversary.

To make the heart, adapt the cutting-foam technique on pages 86–87, using the template on page 118. Here, the foam strips are interspersed with pairs of silvery seed beads and two flat-backed rhinestones are glued securely together to create the larger base bead. The window in the simple, square presentation mount measures 6 × 6in (15 × 15cm) and the neatly taped loop can easily be detached to hang more permanently elsewhere. You could choose a color that celebrates a special wedding anniversary – silver, ruby, or gold, for example – or maybe alternate the favorite colors of both partners.

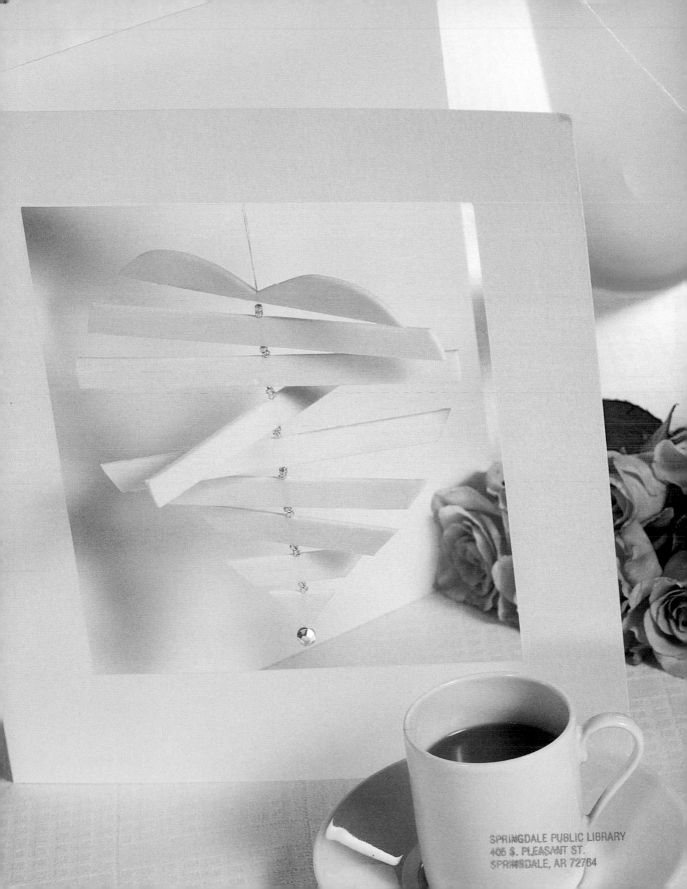

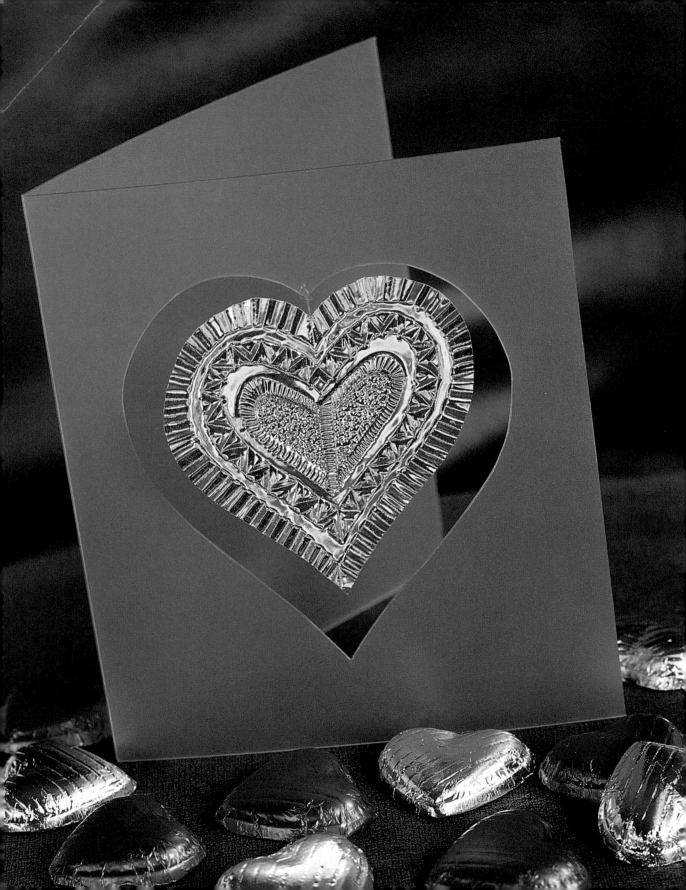

sweet heart

The thick, slightly frosted plastic used for this valentine is teamed with an embossed silver foil heart and hung on transparent nylon thread for a thoroughly modern effect.

Follow the instructions on pages 80–81 and the templates on page 105. It is not easy to cut neat curves into thick plastic but you can quickly smooth out any imperfections with fine-gauge sandpaper.

For a contemporary card with an industrial look, substitute a medium-weight metal embossing foil for the plastic mount; take care to avoid sharp edges. For a more traditional approach, hang a golden brass foil heart on silken thread or fine ribbon within a richly colored paper or fabric-covered mount.

champagne celebration

A card for almost any important celebration, this design looks attractive

as it emerges from its envelope as well as in its opened form.

Adapt the accordion technique on pages 90–91. Use the templates

on pages 120–121, cutting first the glass shapes and then the "liquid"

champagne shapes. Extend the back flap by ½in (1.5cm) and add an extra

4in (10cm) for the extra motif. The plastic for the glasses needs to have

sufficient body to stand up straight without being too thick to cut neatly.

A frosted champagne-colored paper is ideal for the champagne; prick

with different-sized needles to create a subtle bubble effect. You could

simplify the design by using stiff champagne-colored card for the glass

shapes, suggesting the liquid with a fine golden outline, drawn with a pen.

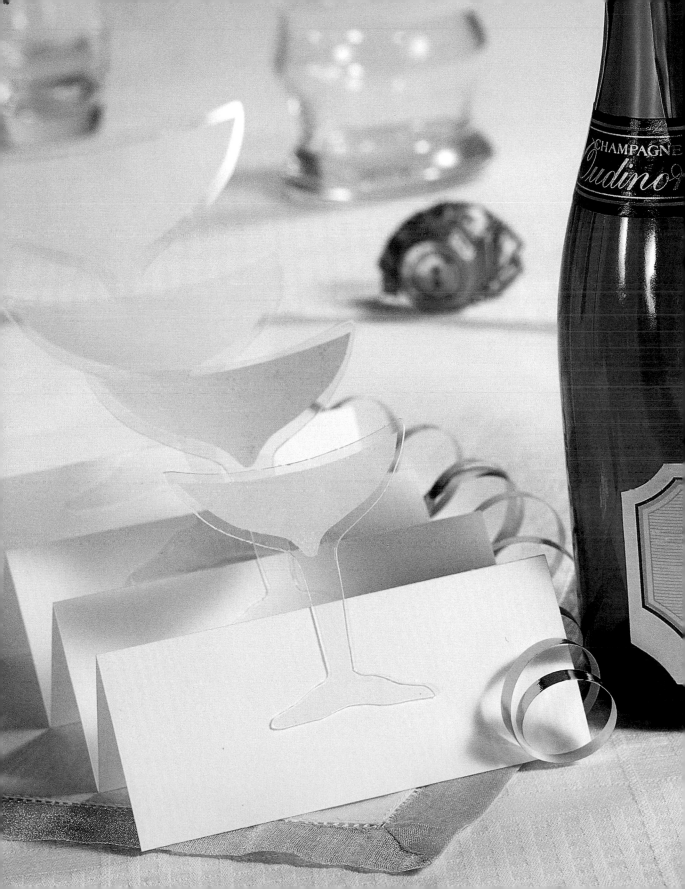

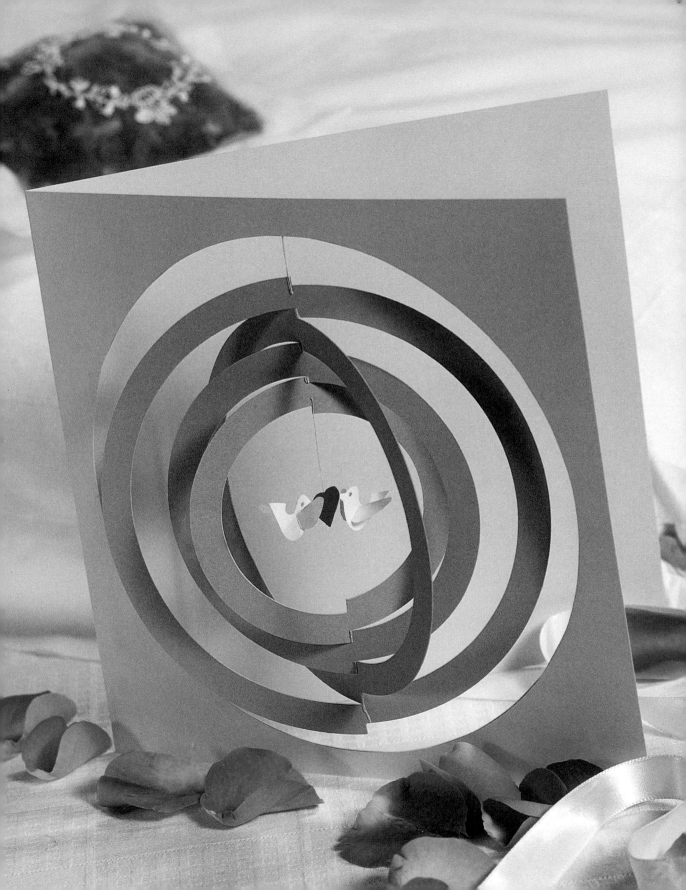

love birds

These amorous love birds make a card suitable for an engagement or wedding. The pearly rings encompassing the birds add a subtle sparkle, in contrast to the bright pink heart they carry.

Adapt the spheres technique on pages 96–97 and use the templates on pages 108–109. Sandwich the birds with a hanging thread centrally between two hearts. Push each wing piece carefully through the body slot to the central fold. Check all of the elements are balanced and the card hangs straight.

You could enlarge the birds and fix them to a small piece of card to make a gift tag or freestanding card. Trim away part of the back wing on each bird and use foam pads to fix the motif, as shown here.

wedding bell

As a wedding card, this silver, slightly frosted bell is impressive as it emerges from its envelope and becomes transformed into a 3-D card when opened and set down.

Follow the turnstiles technique on pages 94–95, and use the templates on pages 114–115. Careful and accurate cutting is vital to ensure that the hinge points are both strong and flexible. Two textured papers act as foils to the elegant silver glitter spray. The couple's initials could be monogrammed on a corner of the card.

The bell motif is also a traditional Christmas theme: white and gold papers would be attractive, or try a stronger pairing of colors, such as gold on red or red and green.

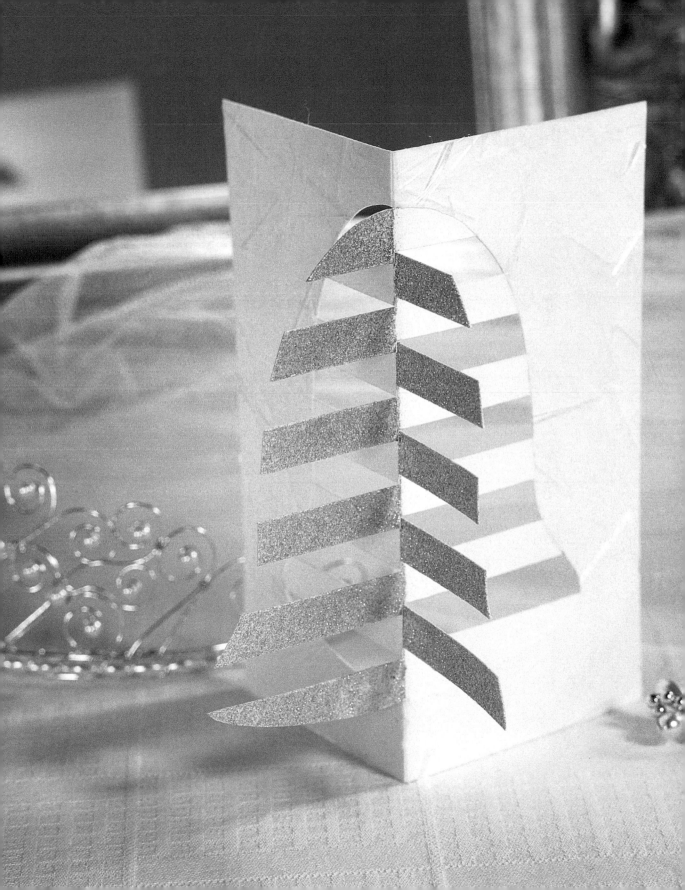

birthdays

This sparkling birthday selection ranges from the surprise of a customized pop-up polyhedron to the simple beauty of a favorite flower or a sweet mobile for the newest baby. Several reflect a recipient's interests — soccer, gardening, sailing, shopping even — and may prompt you to experiment. Most could also be used to wish someone to get well soon, to send thanks, or simply as a general greeting.

camellia bloom

A crisp double camellia with its golden center was the inspiration for this birthday card. Carefully arrange the individual layers of petals within the card for presentation until it looks aesthetically pleasing to you: it will look more balanced and attractive some ways than others.

Adapt the slot-in technique on pages 88–89, using the templates on page 119. For the card mount, line a piece of green paper with a deep yellow that will act as a vibrant background for the dusty rose petal rings. You can leave the center of the flower empty as here or simulate the circle of stamens by sandwiching a layer of clear acetate between the two layers of paper forming the inner petal shape; squeeze a ring of dots and stripes onto it in shades of pearly yellow 3-D fabric paint.

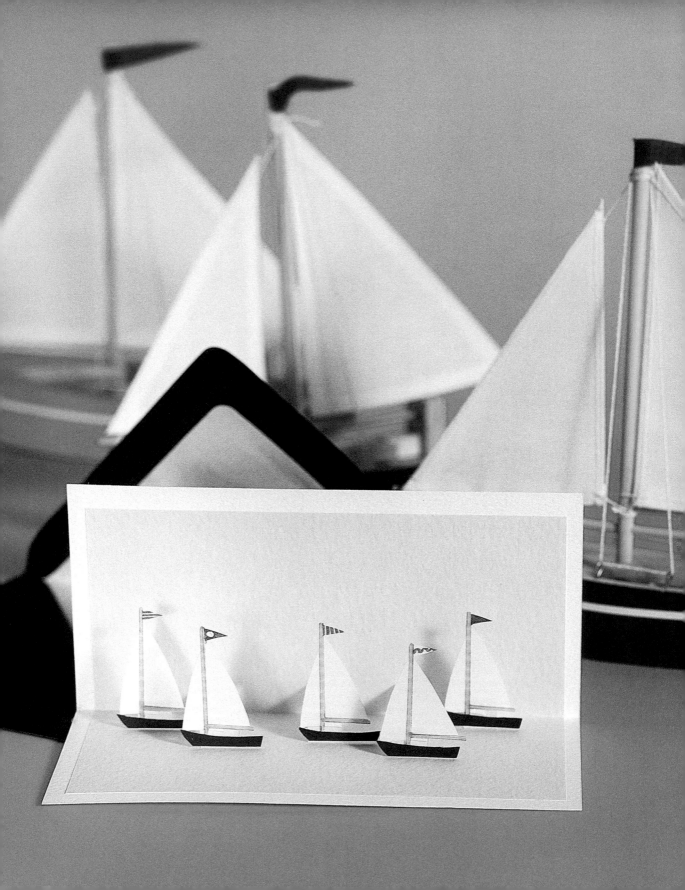

blue marina

A cheerful, summery card for sailors and water-lovers, — pale blue textured paper represents the sea and sky, and the small fleet is festooned with patterned pennants.

Follow the stand-ups technique on pages 100–101 and templates on page 116. High-laid white paper for the boats suggests sails, with further detail added in ink or paper collage. You could paste a simple circle of gold or silver paper to the background for the sun or moon. A deep blue sea is evoked by the paper used for the envelope but you will need to add a contrasting address label if the card is to be mailed.

This is an infinitely variable technique: from dogs or cats, to flowers or vintage cars – select a motif appropriate to any event.

birthday surprise

You need a relatively stout, snug-fitting envelope for this birthday surprise; powered by its rubber band, it should literally spring out of its covering to greet the recipient.

Full instructions for the pop-out box appear on pages 102–103, and the template is on page 117. Absolute accuracy in marking, cutting and matching the two pieces is vital for a sleek and impressive shape.

You can personalize the polyhedron in any number of ways before assembly. Glue on tiny paper cutouts, use miniature stencils, or rubber stamps or experiment with black-on-white op art effects to decorate each facet of the polyhedron. Plan the design carefully to achieve a balanced effect when the shape springs open.

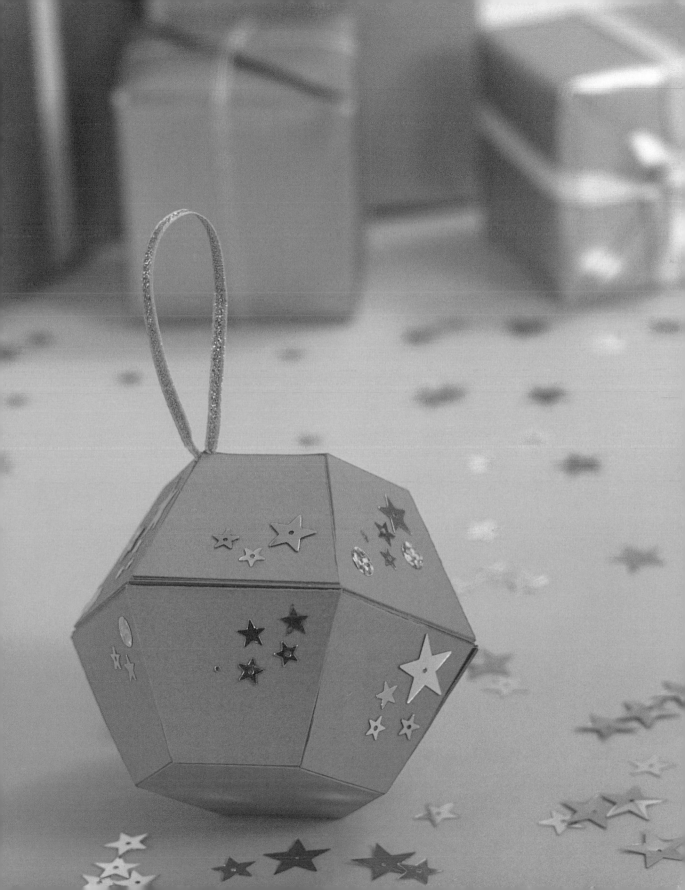

rustic sunflower

The earthy tones and slightly rough papers of this sunflower card will appeal to a friend or family member who loves to garden. It might also make an appropriate card for a child with a pack of seeds tucked inside to spark a new interest.

This card is based on the quilling technique on pages 98–99. Use the template on page 118 as a guide, working out from the tight coils of the flower's center. Four strips begin the stem; the innermost two joined right to the flower, while the outermost curl away to form the leaf stems.

When the flower is complete, brush its underside with PVA glue, fix it to the folded card mount, and add leaves. Draw a margin line in gold. Try quilling flowers with thinner papers in pastels for a more muted look.

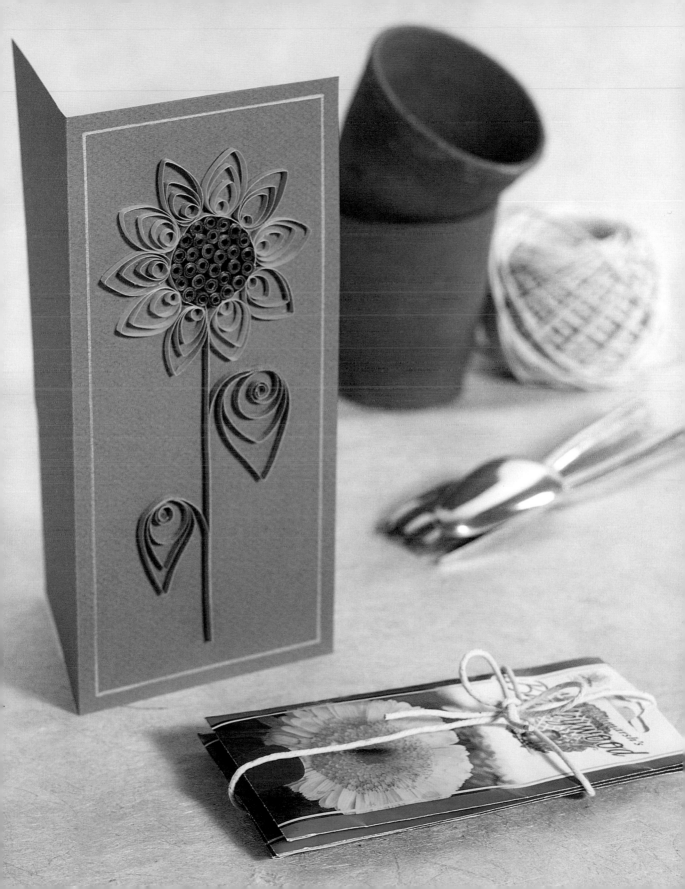

spinning teddy

A card that can be sent in celebration of a new arrival as well as to celebrate an early birthday, it can be hung as a mobile above the baby's crib or changing table.

Adapt the spheres technique on pages 96–97, using the teddy bear template on page 108 and the moon and stars template on page 109. A crisp, mottled paper in soft lilac encircles a teddy cut from cloudy white paper. Add pearly lilac metallic paws and features using a gel pen, and hang the teddy from a silky lilac thread.

As an alternative to the classic pastels, try bolder, brighter, contrasting colors for a more contemporary approach, or choose colors to complement the baby's sleeping area.

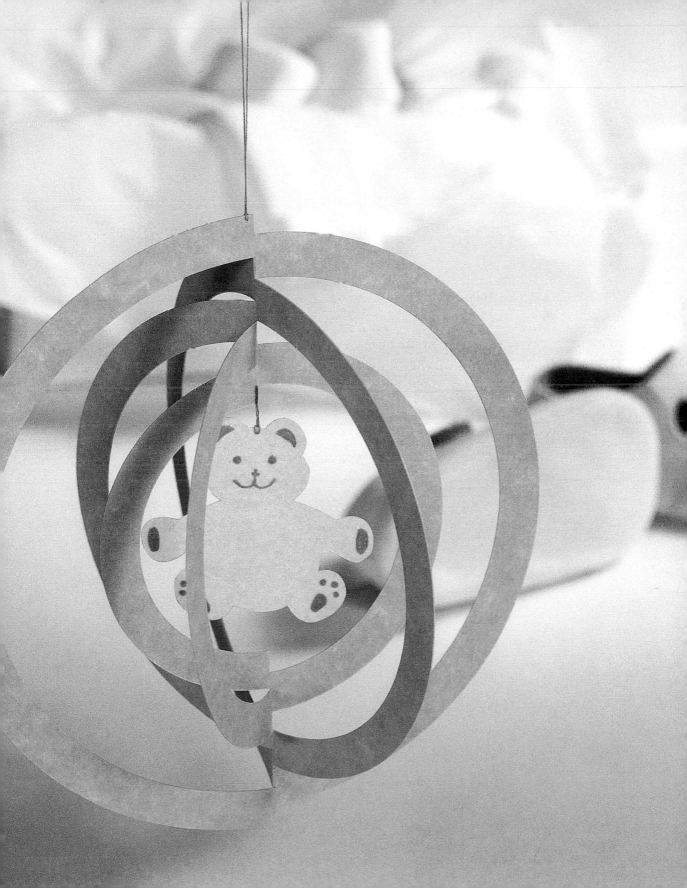

slotted cogs

Precision cutting and modern, hand-finished papers produce a strong greeting card for the mechanically minded. Arrange the cogs with care when you close the card: they will swing to their positions when open.

Adapt the slot-in technique on pages 88–89, using the templates on page 120. Note the tilted axis: the cogs are set diagonally. For the cogs, back rough, holey silver-gray paper with shiny silver paper. Cut in two and glue back to back. Line a contrasting pale warm-gray paper with black for the window card mount.

The card's rugged feel could be altered by the substitution of fine high-gloss and filigree gold papers, suggesting precision antique watch or clock mechanisms.

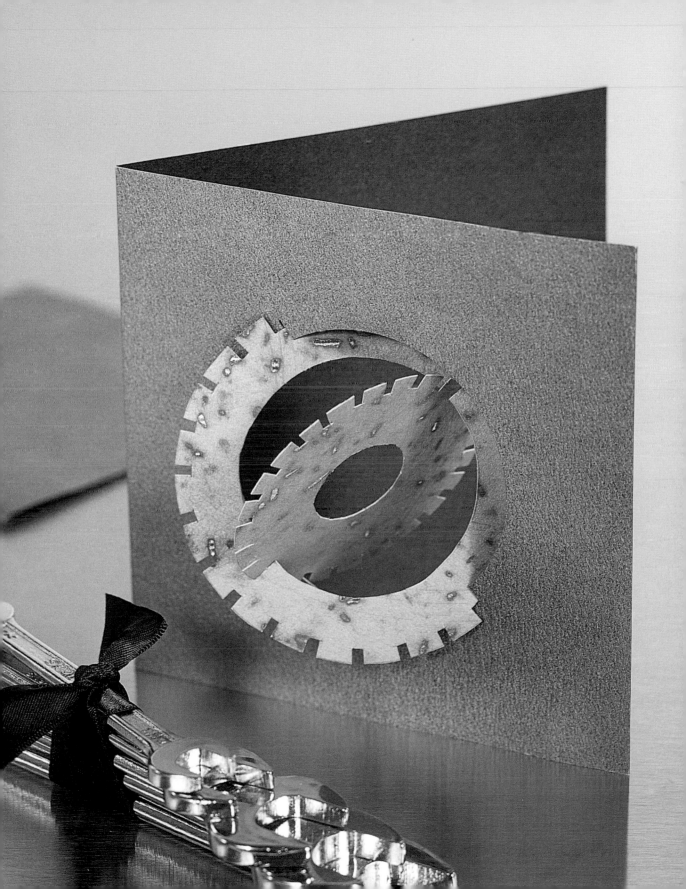

expanding soccer ball

This is a fun card for soccer fanatics – just make sure that you choose the right team colors for the tassel and hanging loop.

Follow the technique on pages 102–103, using the template on page 117 and white card that will not buckle once inked or painted. Paint alternate rhomboids and one of the hexagonal faces black after scoring so it will not crack when bent. Mark the central point on both hexagons and pierce to attach the loop and tassel before assembly. For the loop, twist together ribbon, yarn, or embroidery silks. For the tassel, wrap the yarns around two fingers, slip off, and secure around one end before cutting the loops at the other. Push a strand of yarn through the loop of tassel and the hole to fasten inside before assembling the polyhedron.

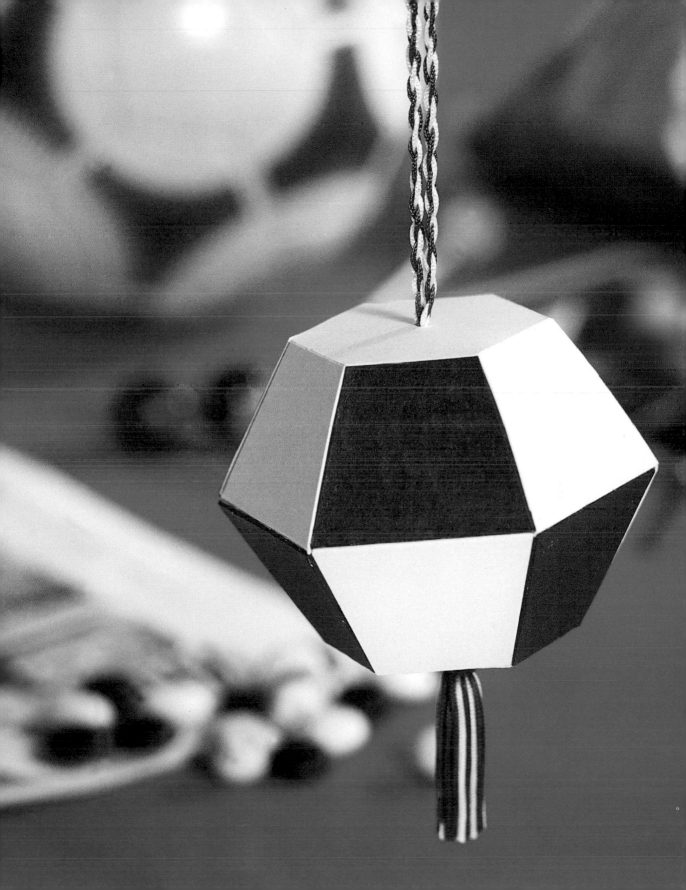

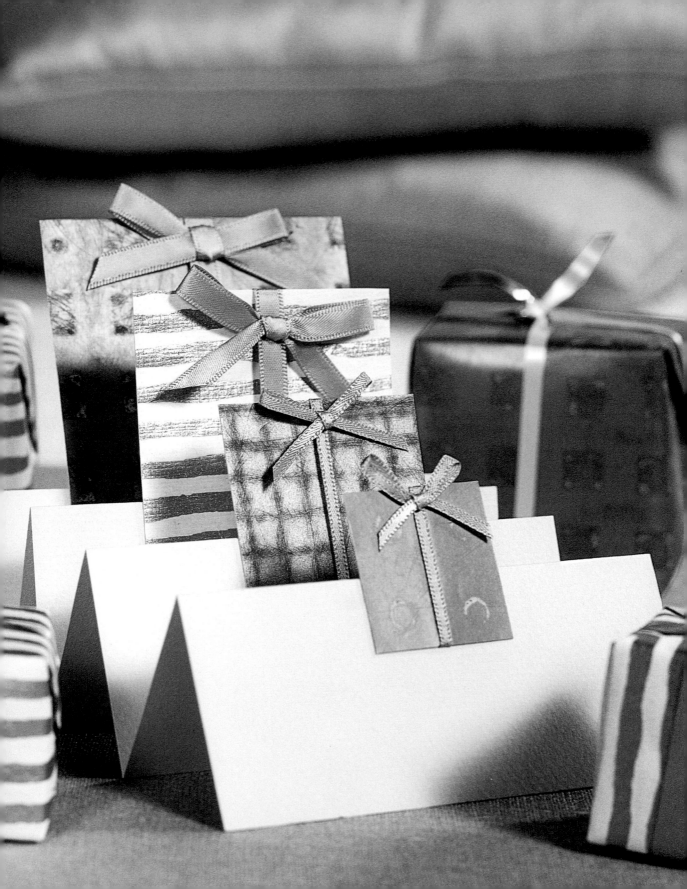

birthday boxes

This array of gift boxes showcases a carefully gathered collection of papers, linked by a common color theme.

Adapt the accordion technique on pages 90–91 for four motifs, cutting the card 4in (10cm) longer and use the templates on page 121. Plain and small patterned papers work best for this card, all set on a neutral background accordion. Matching ribbons of different widths link the packages; wrap the ribbons around the top and and bottom of each package and affix to the back with fabric glue. Finish with matching bows.

The use of different papers instantly alters the mood, from dainty or subtle to bright and bold. A matching envelope made from one of the patterned papers makes the card particularly special.

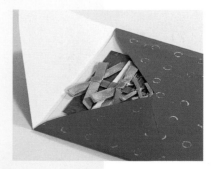

techniques

& templates

Here you will find step-by-step instructions to the basic techniques and all the templates you need to help you make your own cards. Specific variations for individual designs are explained in the project section. If templates require frequent handling, photocopy them directly onto thin card if your copier machine allows this, or glue a paper photocopy onto card before cutting out.

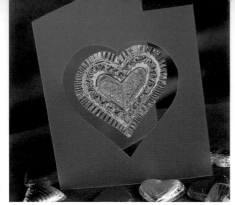

Sweet Heart
See page 52

embossing

This technique uses shallow surface impressions, worked from both sides of the material, to create relief decoration on lightweight metal foil.

Photocopy both templates on page 105 onto thin card and cut out, following the outer line of template A. Use scissors to cut a small piece of foil and transfer template A to the foil by drawing around the outline with a pencil. Try to avoid touching the foil if possible because it is easily marked with fingerprints.

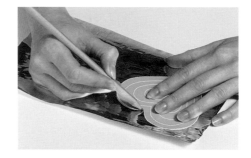

Cut around the marked outline, holding the waste foil wherever possible. In step 3 you will be cutting down template A, so if you plan to make several Sweet Hearts, prepare the foil hearts all at once and carry out each instruction on all cards stage by stage. Alternatively, make several copies of template A.

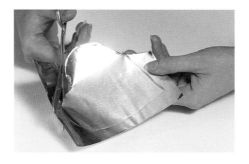

Reduce template A to the next largest heart size by cutting on the line nearest to the edge. Center the smaller template A on the foil heart and emboss its outline into the metal by drawing around it. Reduce template A to the next size and repeat. Reduce again and reverse the foil to emboss the remaining lines.

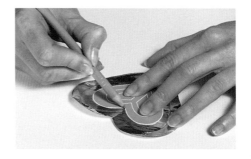

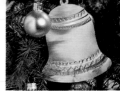

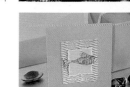

Golden Bell
See page 14

For the Sweet Heart you will need:

Templates on page 105 • Thin card • Lightweight artist's metal foil • Scissors • Hard, sharp pencil or embossing tool • Pink polypropelene or card • Ruler • Craft knife • Cutting mat • Fine sandpaper • Strong needle • Fine nylon thread

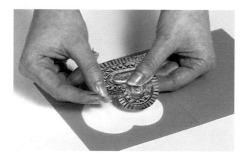

Silver Fish
See page 34

Now begin to make a series of contrasting patterns between the embossed lines. Here the outermost zone is given a pleated effect. First mark a series of even, well-spaced radial lines, using the pencil; then turn the heart over and bissect each of the spaces between the lines with another embossed line.

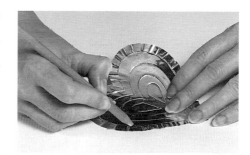

Work inwards through the zones, alternating plain and patterned bands. To make a zigzag pattern, mark the basic shape from edge to edge of the band and then turn the metal and add unconnected Vs within the spaces in the pattern. Finally, press a series of dots from both sides into the inner lobes.

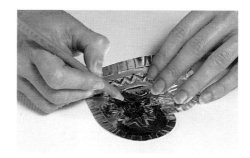

Cut a mount 7⅞ x 5⅞in (20cm x 15cm) with the craft knife. Score to fold and sand to finish. Using template B, mark the heart on the front and cut out. Bore two holes: center top over the cut-out and at the top of the foil. Thread a nylon loop through the plastic, loop the ends, thread one through the foil, and tie.

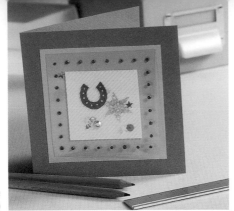

layering

Lucky Horseshoe
See page 40

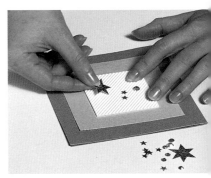

Fold the blue base paper in half, scoring with a craft knife if necessary; then cut to make a card 5¹/8 x 5¹/8in (13 x 13cm) square. Cut a 4in x 4in (10 x 10cm) square of gray paper and an acetate square 3³/4 x 3³/4in (9.5 x 9.5cm). Glue the gray square centrally on the card front, setting the acetate aside for step 5.

Cut the innermost, white square, measuring 2³/8x 2³/8in (6 x 6cm), from fine corrugated paper. The effect will be more interesting if you cut so that the ribs run diagonally across the square, but take care to ensure that they are not squashed or snagged in the process. Glue the shape centrally on the gray square.

Use the template on page 111 to cut horseshoe from metallic paper. Begin t explore different compositions using th horseshoe as the focus of your design an trying out sequins, flat rhinestones, and silve paper or hologrammed stars. Take care no to overcrowd the arrangement.

For the Lucky Horseshoe you will need:

Two toning papers • Craft knife • Cutting mat • Ruler • Pencil • Scissors • Acetate sheet • Glue stick • Fine corrugated paper • Template on page 111 • Metallic paper • Sequins, rhinestones, and stickers • All-purpose glue • Three-dimensional metallic craft or fabric paint

Evergreen Ring
See page 20

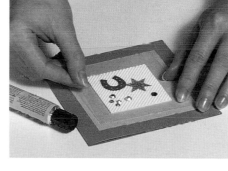

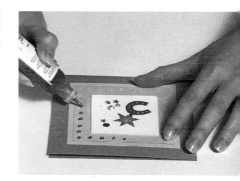

Decorate the horseshoe with a silver metallic pen to represent nail holes before gluing in its final position. Then stick or glue most of the remaining elements in place. A toothpick or pin is helpful when applying glue to tiny pieces. Set aside a few extra sequins to shuffle freely behind the acetate.

Squeeze dots of all-purpose glue all round the border that surrounds the white square, placing them at approx. ¹/₂in (12cm) intervals from the outer edge of the gray paper. These will secure the acetate. Add the loose sequins, position the acetate and weight the glue lines from the outside until dry.

Using a complementary metallic-colored paint, pipe neat, peaked dots round the acetate, both to conceal the glue spots and to add a final decorative touch. It is worth practicing on spare acetate first. Allow plenty of time for the paint to dry: it shrinks slightly and the peaks will squash if pressed too soon.

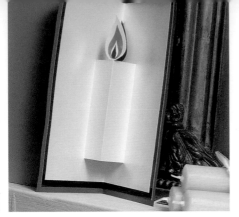

Candle Glow
See page 26

pop-ups

A single sheet of paper is cut, folded, and mounted on backing card to achieve the element of surprise in this three-dimensional effect.

Photocopy the templates on page 113. Cut a piece of cream card to the same size as the square template and secure the template to the right side of the card with strips of removable tape. Using the craft knife and straight edge, cut through both layers just along the solid lines of the candle shape.

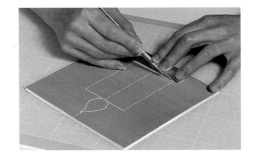

Use the craft knife (or scoring tool) and straight edge as a guide to score only the dotted lines on the template. Carefully remove from the card, detaching the tape. Gently ease the spine above and below the candle shape downwards into a "valley" fold and the candle itself upwards into a "mountain" fold.

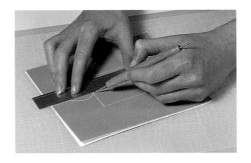

Cut two squares for the mount: the inner, shiny one $6^5/8 \times 6^5/8$in (17 × 17cm) and the matte one approx. $7^1/8 \times 7^1/8$in (18 × 18cm). Fold each square in half, scoring if necessary. Glue the purple papers together at the spines and then the edges. Finally attach the pop-up, gluing only the valley folds and outer edges.

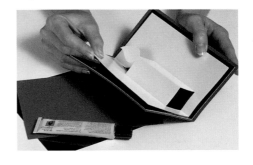

Four-Leaf Clover
See page 42

For the Candle Glow you will need:

Templates on page 113 • Glossy cream card • Pencil • Ruler • Craft knife • Cutting mat • Removable tape • Scoring tool (optional) • All-purpose glue• Straight edge • Scissors • Metallic paper • Toning double-faced matte paper • Toning metallic paper scraps in three colors

Rock-Solid Heart
See page 48

Plan the color sequence of the metallic paper scraps and use the flame templates to draw and cut out the three shapes. Small-bladed or manicure scissors may help. Paper-backed metallics are often easier to mark on the reverse, but be sure to turn the templates so the shapes still echo the curve of the flame.

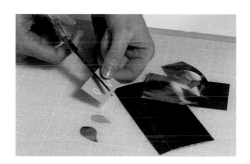

Assemble the three-layered metallic flame, arranging the smaller shapes so that they lie almost at the wide base of the largest shape. Use just the tiniest dots of glue and leave to dry thoroughly. A toothpick or the head of a pin is a useful way to control the amount of glue you apply.

Open the card to check the position of the flame decoration: it should lie very near the base of the cream flame shape. Lay the opened card flat and glue the decoration to the pop-up. You could, as a final touch, cut a second decoration and glue it to the bottom corner of the otherwise plain cover.

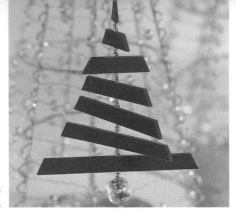

Twirling Tree
See page 16

cutting foam

Densely textured yet featherlight, colored craft foam is cut and assembled to create a perfectly balanced and ever-changing hanging card.

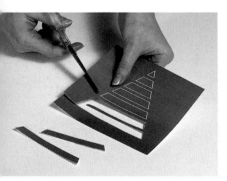

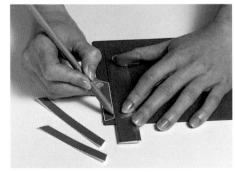

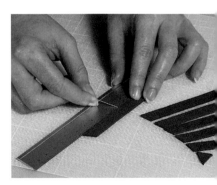

Photocopy the Twirling Tree template on page 106 and rule a faint line between the centre points. Using a pair of fine scissors, cut out from the template each of the strips that make the tree shape (if you prefer, use a craft knife and ruler). Using the template this way will make the best use of your foam.

Place each template strip on top of the foam and draw the outlines of the strips onto the foam using the pencil. Use a ruler or other straight edge to guide you. Cut out the strips. You should finish with seven pieces of foam, each measuring approximately ½in (1cm), including the triangle for the top of the tree.

To indicate the line of the hanging thread lightly but firmly mark the center point of each section by scratching with the needle across the thickness of the foam at the top and bottom. The center line ruled through the entire template before the sections were cut out will guide you or use a ruler as shown

For the Twirling Tree you will need:

Template on page 106 • Ruler • Pencil • Scissors • Craft foam
• Craft knife • Straight edge • Cutting mat • Needle • Fine
metallic thread • Shiny seed beads to complement main bead
• Large, heavy bead • All-purpose glue

Soft Hearted
See page 50

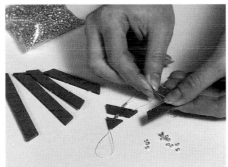

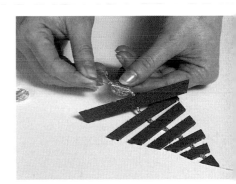

Cut a length of thread more than twice as tall as the tree (allowing for a loop and for tying off), double it and thread the ends through the eye of the needle. Carefully ease the needle and thread straight down through the foam at the center points of the triangle, leaving a good-size loop for hanging.

Thread three seed beads after the triangle. Repeat, threading each section through the thickness of the foam at the exact center to ensure perfect balance and following with three more beads until all the sections are threaded. Add only two beads after the final section and then the larger bead.

Thread a last seed bead, passing the needle through twice to hold it securely. Then work the needle back through the beads at the base and the lowest section before cutting the thread. A dot of glue in the bore of the last bead adds extra security. Gently ease all the elements down to avoid gaps if necessary.

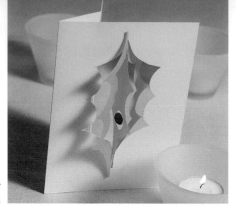

Holly and Berry
See page 12

slot-ins

Simple paper engineering: decorative interlocking shapes in different colors slot into a window cut-out to create a three-dimensional design.

Photocopy all four templates on page 104 and cut out template A. Cut a piece of white card measuring 7⁷/₈in × 5⁷/₈in (20cm × 15cm) and fold in half, scoring carefully with a craft knife if needed for a crisp spine. Center template A on the card front, keeping it perfectly vertical, and draw around it with a pencil.

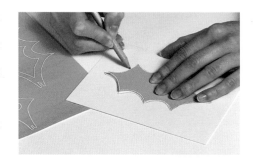

Carefully cut along the pencil line on the front, using scissors or a craft knife, and discard the white leaf shape. If you choose a craft knife, work on a firm, non-slip surface, such as a cutting mat, and open the card first to avoid marking or cutting right through both sides. Erase any remaining pencil marks.

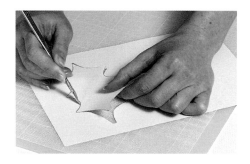

If you wish, you can fold the back of the card so that the holly leaves at the front are viewed more clearly. Mark a line on the plain back section of the card, parallel to the spine and about 2in (5cm) from it. Scoring lightly if necessary, fold along this line, away from the leaf-shaped window.

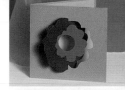

Camellia Bloom
See page 62

For the Holly and Berry you will need:

Templates on page 104 • Scissors • Craft knife • Cutting mat •Ice-white card • Ruler • Pencil • Eraser • Straight edge • Translucent green paper • Red paper foil scraps • Fine green cotton thread • Clear, all-purpose glue • Matte or shiny adhesive tape (optional)

Slotted Cogs
See page 72

Cut out and discard the inner sections of templates B and C. Use the templates to make two holly leaves, cutting the outside lines first. Assemble to check that the small leaf slots into the large one, and the large leaf fits into the opening, while both can move freely. Shave the inside of the appropriate slot if necessary.

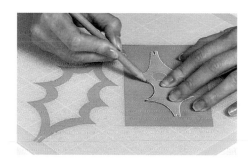

Using the foil paper and berry template, cut out two circles. To ensure a perfect match, you can fold the foil in half and cut both layers together. Lightly glue the fine cotton thread to the back of one circle and then cover with the second, aligning them carefully back to back, to create a double-sided red berry.

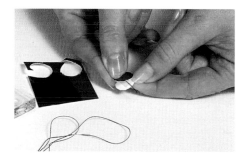

Remove the leaves from the card and check the position of the berry – it should hang centrally within the hole on the small leaf. Trim the thread to allow a slight overlap onto the leaf and secure unobtrusively: depending on the leaf material use shiny or matte adhesive tape or clear glue. Reassemble.

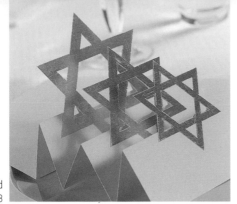

Star of David
See page 28

accordion

A repeated motif, varied only in size and mounted on folded paper: this design can easily be extended by adding 10cm (4in) for every extra fold.

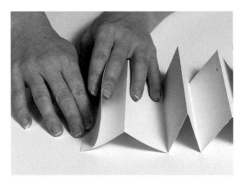

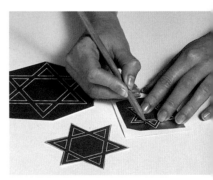

From creamy paper stiff enough to support the motifs, cut a rectangle 16½ × 4¾in (42 × 12cm). Measuring from one end, lightly mark both edges of the shape at 4¾in (12cm) and then at 2in (5cm) intervals to indicate the three folds. Using the craft knife and straight edge, score the strip along each line.

Carefully fold the strip along the scored lines, first one way and then the other to make the accordion shape as shown. The long section at one end will act as a backing frame for the motifs when the card is closed. If the scored lines are perfectly accurate, all the layers will overlap exactly at the sides.

Photocopy the star templates on page 10 and cut out. Use glue stick or another quick drying, non-wrinkling adhesive to back a small sheet of gold paper with more stiff paper Position the templates on the gold paper with tiny strips of removable tape, taking any grain into account, and mark the star outline.

For the Star of David you will need:

Stiff cream paper or thin card • Ruler • Pencil • Scissors • Craft knife • Cutting mat • Straight edge • Templates on page 108 • Glue stick • Glossy gold paper, possibly textured • Removable tape • Double-sided tape

Champagne Celebration
See page 54

Birthday Boxes
See page 76

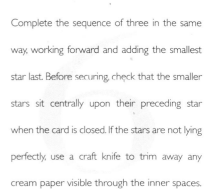

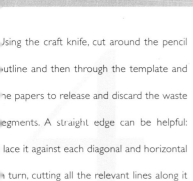

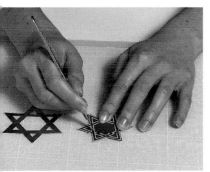

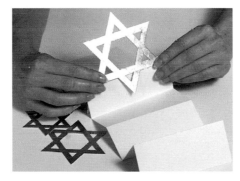

Using the craft knife, cut around the pencil outline and then through the template and the papers to release and discard the waste segments. A straight edge can be helpful: place it against each diagonal and horizontal in turn, cutting all the relevant lines along it accurately. Remove the templates carefully.

Center the largest star on the front of the accordion section nearest the backing frame. The top of the star's lowest horizontal bar aligns with the fold itself and its upper points are framed by the backing flap when the accordion is closed. Secure with a strip of double-sided tape along the fold.

Complete the sequence of three in the same way, working forward and adding the smallest star last. Before securing, check that the smaller stars sit centrally upon their preceding star when the card is closed. If the stars are not lying perfectly, use a craft knife to trim away any cream paper visible through the inner spaces.

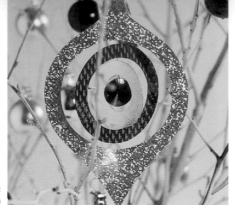

Hologram Bauble
See page 10

pendants

Repeating cut-paper shapes set one within the other for a design inspired by a set of Russian dolls: holographic and metallic papers give added depth.

Photocopy the templates on page 107. Plan the sequence of papers, alternating color and finish. There are two ways to cut the shapes. Method 1: cut out templates A to D, discarding the centers of A to C; mark and cut two shapes for all four templates from your chosen papers.

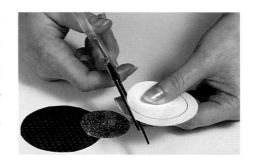

Method 2: cut templates A to D; fold each paper with right sides together, secure the four templates to your chosen papers, using removable tape, and cut through all the layers at once. Whichever method you use, work on the white reverse of holographic material. Set aside shapes to be glued in steps 4 and 5.

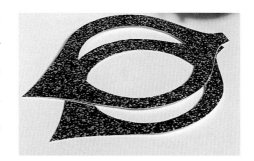

Using template E and foil, cut two shapes to decorate the top of the card. You can, if you prefer, cut both crowns out together. Again, fold a small piece of foil in half, right sides facing, before placing the straight edge of the template to the fold, marking and cutting out; turn right sides out without cutting the fold.

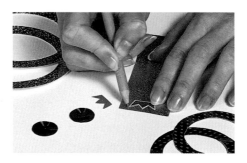

For the Hologram Bauble you will need:

Templates on page 107 • Holographic and metallic papers in four complementary colors • Scissors • Pencil • Removable tape (optional) • Scrap of gold or silver foil • Fine decorative thread • All-purpose glue • Needle (optional)

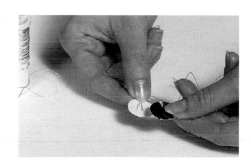

New Home
See page 44

Cut the doubled thread to reach from the center of the card up beyond the outer ring, allowing for a generous hanging loop. Glue both ends to the back of one central circle, making sure the threads emerge together from one side. Add more glue and lower the other circle, right side up, into place.

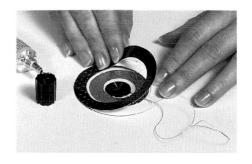

Repeat the process with the other pairs of shapes. Working outwards, keep the threads taut and center each ring on the previous one. Take great care to ensure perfect alignment at every stage, checking the fit on both sides before the glue dries. Fine papers require drier glues: experiment on scraps if in doubt.

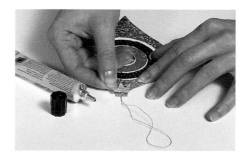

To finish, glue the cap into position, points facing downward, just where the looped thread emerges. If you cut two separate shapes, then place one on each side. If you cut two from a folded piece of paper, use a needle to thread the loop carefully through the center of the fold and slide into place before gluing.

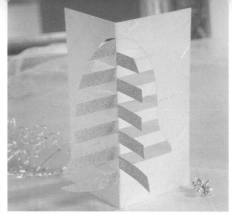

turnstiles

Simple but perfectly accurate paper cutting creates an appealing three-dimensional form that reflects a pedestrian turnstile with horizontal, radiating arms.

Wedding Bell
See page 58

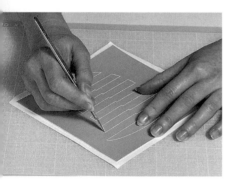

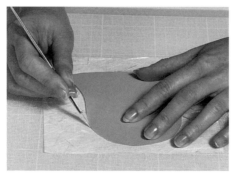

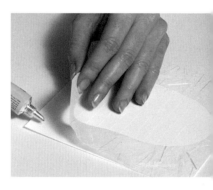

Photocopy the template A on page 114 and cut out the frame. Cut a slightly larger square of white paper and center A on it with removable tape. Use a craft knife and straight edge to cut the horizontal lines through both layers, working from the center. Cut the solid outline of the bell to release alternate arms.

Photocopy template B on page 115 and cut out. Place in the center of a square of the translucent paper, allowing a wide margin all round. Cut out and discard the bell shape. Some textured papers are easier to cut with sharp scissors – to avoid dragging – but you will have to draw around the template first.

Check that any pencil lines are fully cut away before you position the translucent paper frame accurately on the white paper. The bell-shaped cut out should align exactly with the bell outline on the paper. Glue the two together. Choice of glue will depend on the papers used: it must not show through.

For the Wedding Bell you will need:

Templates on pages 114–115 • Scissors • Stiff white paper • Removable tape • Craft knife • Cutting mat • Straight edge • Translucent, white handmade paper • All-purpose glue • Scoring tool (optional) • Waste paper • Newspaper • Silver glitter spray

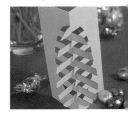

Easter Egg
See page 32

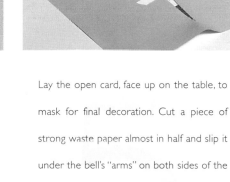

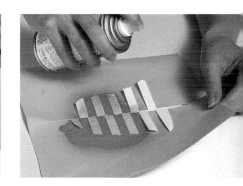

urn the card over and trim the translucent aper flush with the white paper. Referring to he dotted lines on A, score the back very ccurately against a straight edge along the pine at the tiny vertical hinge points and bove and below the bell. Ease the card to old with the translucent paper outside.

Lay the open card, face up on the table, to mask for final decoration. Cut a piece of strong waste paper almost in half and slip it under the bell's "arms" on both sides of the hinges. Ensure that each side of the paper butts as snugly as possible to the center and tape the slit at the bottom to stop seepage.

Mask a large area in a well-ventilated room with newspaper and, following manufacturer's instructions, spray a series of fine mists of glitter over the exposed areas, allowing each layer to dry before spraying again. This creates a much more effective finish than one or two thicker coats. When dry, remove the mask.

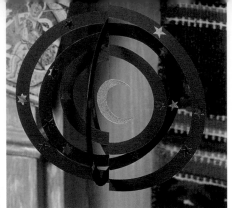

Moon and Stars
See page 30

spheres

Simple cutting, acccurate scoring, and careful folding create a subtle and elegant form that plays on the idea of two pairs of circles at right angles to each other.

Photocopy the templates on page 109. Cut around the outer lines of the semicircles template and tape to the card. Working with a craft knife, cut the semicircles on one side and then the other, taking care not to extend the lines. Or cut the semicircles with a bladed compass, using the center dot.

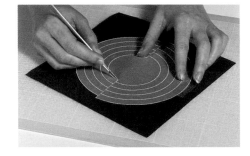

Using a straight edge, score down the intermittent dotted lines which separate the semicircles. Do not extend these hinge points: the unscored sections must stay straight and strong. Cut away any waste from around and within the shape, remove template, and ease the card open along the score lines.

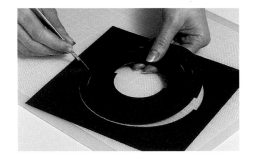

Flatten the card again and cut some tiny stars in the semicircles of paper by superimposing two equal-sided triangles, one point up over one point down. Take care not to weaken the paper by cutting too close to the edge. Check the effect by opening the card again and add star stickers, trimmed to fit.

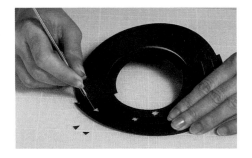

96

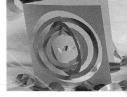

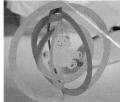

Love Birds
See page 56

Spinning Teddy
See page 70

For the Moon and Stars you will need:

Templates on page 109 • Scissors • Stiff blue paper • Removable tape • Craft knife and (optional) bladed compass • Cutting mat • Straight edge • Star stickers • Pencil • Gold or silver paper scraps • Clear, all-purpose glue • Blue cotton • Needle

Cut out both moon templates very neatly and then mark and cut out two crescent moons on a scrap of gold or silver metallic paper. The two crescents will be stuck together, back to back, and suspended by a piece of thread (see step 5). Mark the hanging point discreetly on the top edge of the moons.

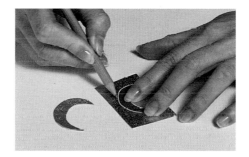

Lay one crescent moon face down and, with a dot of glue, secure one end of a short length of cotton so that it extends outwards at the hanging point. Check that the balance is right before adding more glue and lowering the second moon into position. Make sure they are perfectly aligned before leaving them to dry.

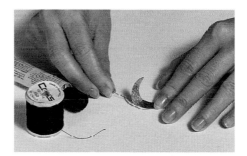

To attach the cotton to the top of the inner semi-circle, trim to length and glue. To make the hanger, knot a loop of cotton and, using the needle, thread it through the center top of the outermost semicircle; draw the knot through the loop and tighten. Open the card until the semicircles hang at right angles.

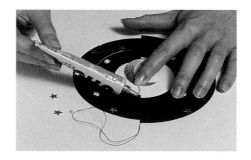

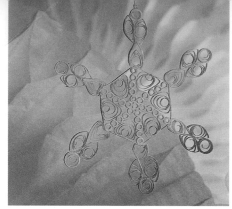

quilling

Narrow cut-paper strips are rolled, shaped, and assembled to form delicate lacy designs – this traditional craft is also known as paper filigree.

Snow Crystal
See page 18

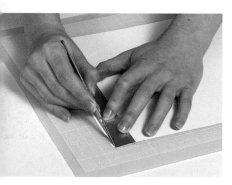

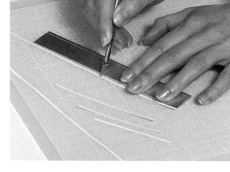

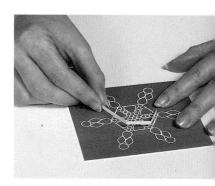

Photocopy the underlay on page 106 onto thin card and protect with a sheet of acetate taped into position to avoid slippage. A clear plastic bag will do the job too but take care to secure it firmly. Cut the quilling or lightweight paper into strips 1/8in (3mm) wide, using a sharp craft knife and straight edge.

White and pale blue papers have been prepared here but you may prefer to use white strips throughout. Pre-cut quilling strips are available from craft shops in a wide range of colors but cutting your own from paper does not take long. Be sure to choose a thin, crisp paper.

Glue two white strips together to make stiff quill of double thickness. When dry, cut 5 1/4in (13.5cm) length and score the quill s times at 4/5in (2cm) intervals, allowing for small final overlap. Fold gently at the scor marks to form the hexagon, checking fc crisp corners. Glue the overlap to secure.

For the Snow Crystal you will need:

Underlay on page 106 • Thin card • Acetate or clear plastic
bag • Adhesive tape • Scissors • Quilling or lightweight paper
• Ruler • Craft knife • Cutting mat • Straight edge • PVA glue
• Quilling tool or bamboo skewer • Decorative thread

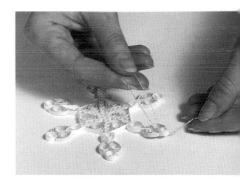

Rustic Sunflower
See page 68

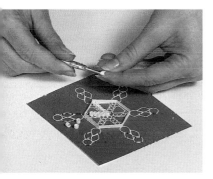
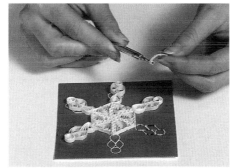
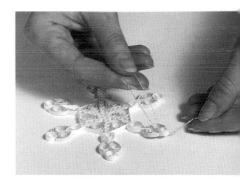

repare approx. 31 tight white rolls from strips
⁴/₄in (6cm) long. The number will depend on
e width of the tool you use. Wind each paper
p firmly, keeping the roll tight as you secure it
ith glue, and hold until dry. Place the hexagon
n the underlay and, working from the center
utwards, glue the rolls together as shown.

For looser rolls, wind 4in (10cm) long papers
but let the roll drop off the tool and unwind to
the right diameter before gluing. Make six
white ¹/₄in (6mm) diameter rolls, twelve blue
and six white ³/₈in (10mm) diameter rolls, and
six blue ¹/₂in (12mm) diameter rolls. Use the
underlay and picture to shape rolls as required.

Glue each roll in place, avoiding the underlay as
much as you can, although the acetate or plastic
will make it possible to detach the snow crystal
if necessary. To make the hanger: knot a loop of
decorative thread, pass one end through the
outermost roll on one arm of the crystal, draw
the knotted end through the loop and tighten.

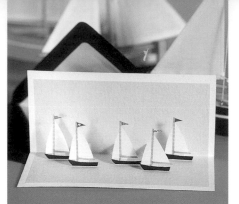

Blue Marina
See page 64

stand-ups

A more elaborate version of the pop-up technique (see pages 82–83): extra motifs are cut and decorated before they are fixed to simple cut-out bars.

Photocopy both templates on page 116, using thin card for the yacht template because you will need to draw around it several times in step 5. Then cut a piece of blue paper to the same size as the pop-up template and secure the template on top of the blue paper, using removable tape.

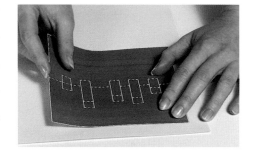

Cut firmly and neatly through both layers, working along all the solid lines. These form the strips that will become pop-up bars. Use a straight edge for really accurate cutting. Lightly score the dotted lines, taking special care not to extend the scoring along the central fold onto the pop-up bars. Remove the tape.

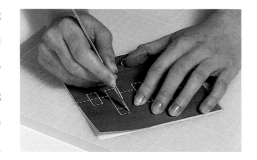

Ease the paper into a downward, "valley" fold along the central scored line. This will begin to push the pop-up bars outward – gently fold the scored lines on each bar to make crisp angles. Cut a piece of white card 5³/4 × 6in (14.5 × 15.5cm). Score and fold in half along the shorter side.

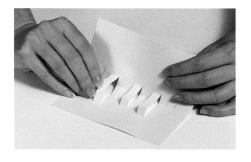

Dancing Snowmen
See page 22

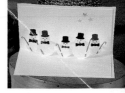

Farewell Wishes
See page 38

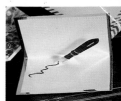

For Blue Marina you will need:

Templates on page 116 • Thin card • Blue paper • Scissors • Removable tape • Craft knife • Cutting mat • Straight edge • White card • Glue stick • Fine scissors • Paper scraps • Coloured inks or pencils • Double-sided tape (optional)

Apply glue to the spine of the prepared blue pop-up, avoiding the pop-up bars themselves, and position it to fit snugly into the spine of the white card. Working quickly and evenly from the spine outwards along all the edges, glue and fix the blue paper, making sure that the card will open and close successfully.

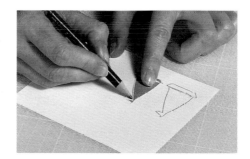

Using fine-bladed scissors, cut out the yacht template and prepare five white paper yachts. Cut out paper scraps to make boldly colored hulls. Use a sharp pencil and straight edge to outline the mast and boom on each boat. Color and add a different pennant to each, using pencils or inks.

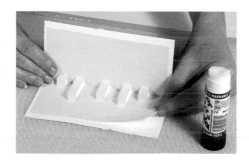

Open the card and, using a tiny dot of glue or a narrow strip of double-sided tape on the back of each hull, secure one yacht to the short, vertical face of each pop-up bar, concealing as much of the bar as possible. It is easiest to work from the spine forward, fixing yachts to the shorter bars first.

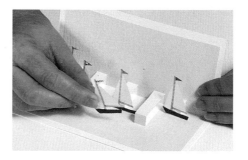

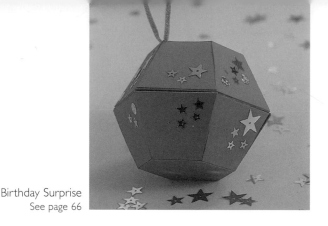

pop-out boxe

A small elastic band and a crochet hook create a simple but ingenious spring action. Inside a tight-fitting envelope, it is a surprise just waiting to happen.

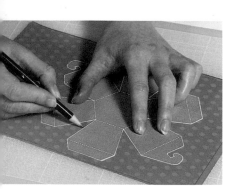

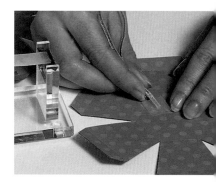

Photocopy the template on page 117 on thin card. If joining papers, use a glue stick to avoid wrinkles. (Here shown as blue outside, ocher inside.) Lay the paper/card face down, draw around the template and cut out, taking extra care with the acute angles. Turn the template over to mark and cut the reverse half.

Working on the outside surface of each half of the box and using the template as a guide, score very carefully with a craft knife and straight edge along all the dotted lines. Practice on a piece of joined paper or scrap card to assess the correct pressure for the job. Accurate cutting and scoring are vital.

Fold each half inwards along the scored line and reopen. Lay one half face down an doubling the ribbon to form a decorativ loop for hanging, tape the loose ends at th edge of the central hexagon so that the loc faces outwards and can be pulled through the outside as the box is assembled.

For the Birthday Surprise you will need:

Template on page 117 • Thin card • Two complementary thick papers or double-sided thin card • Glue stick (for paper) • Pencil • Craft knife • Cutting mat • Straight edge • Ribbon • Adhesive tape • All-purpose glue • Stick-on shapes and sequins • Rubber band • Crochet hook

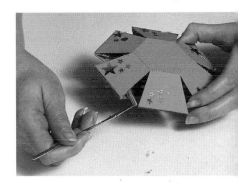

Expanding Soccer Ball
See page 74

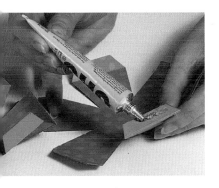

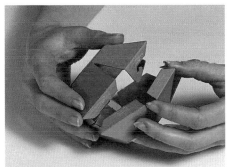

Before gluing the two halves together, check which of the two possible alignments is the more accurate and mark discreetly. Carefully squeeze a thin line of glue along all the flaps of one piece, including those with the hooks. Take care not to over-glue as this could cause a flap to stick to the inside of the box.

Keeping the ribbon to the outside and away from the glue, join the two halves, matching each edge exactly. Weight the box until dry. Decorate the facets with stickers and glued sequins, linking the design from face to face and leaving the top free for a message. (You may prefer to do this once the box is sprung.)

Hold the box slightly open with one hand and gently maneuver the rubber band inside the box and then over one of the paper hooks. Use the crochet hook to stretch the other end of the band across to the second hook. The card now has a spring action, folding flat only when it is squeezed.

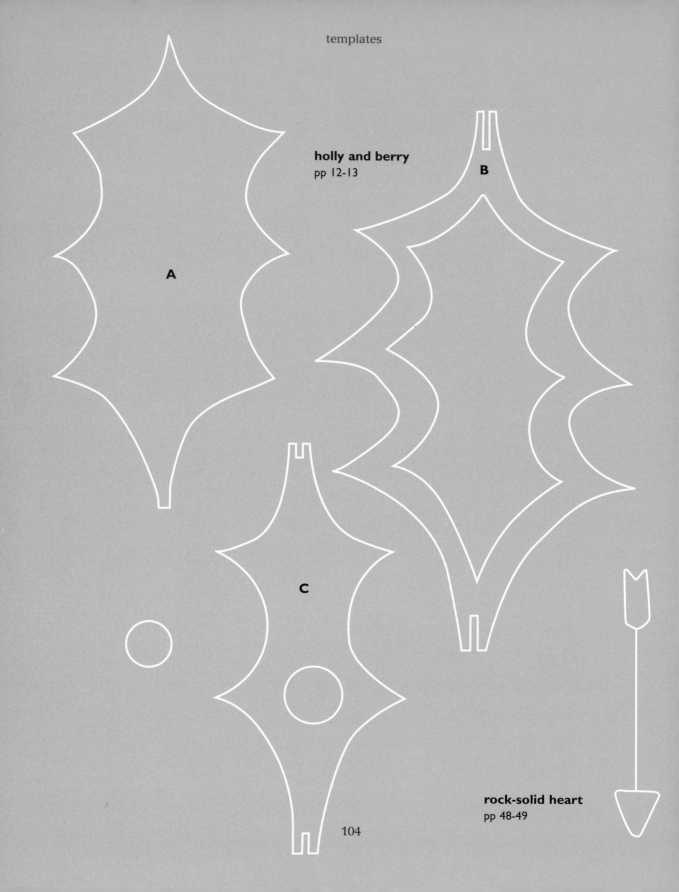

holly and berry
pp 12-13

A

B

C

104

rock-solid heart
pp 48-49

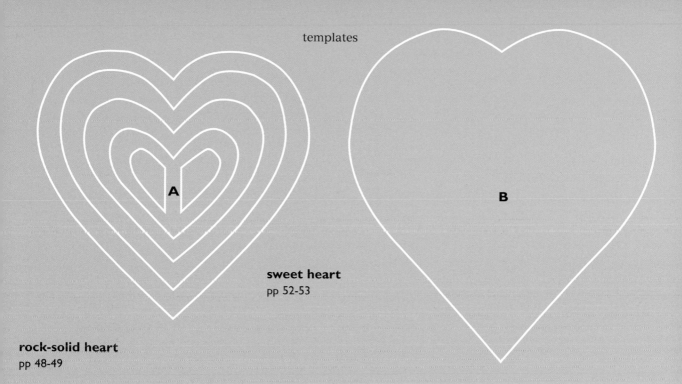

sweet heart
pp 52-53

rock-solid heart
pp 48-49

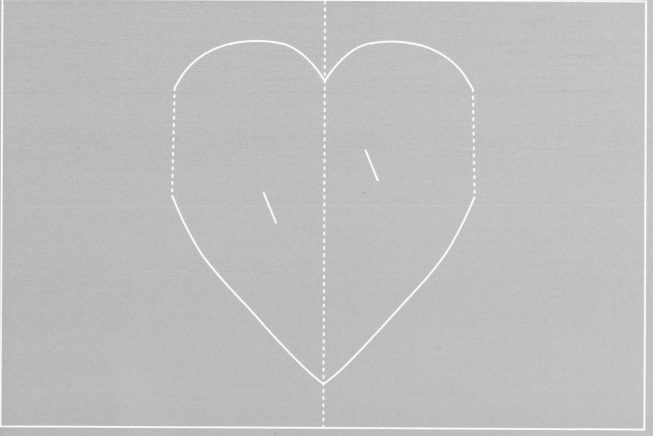

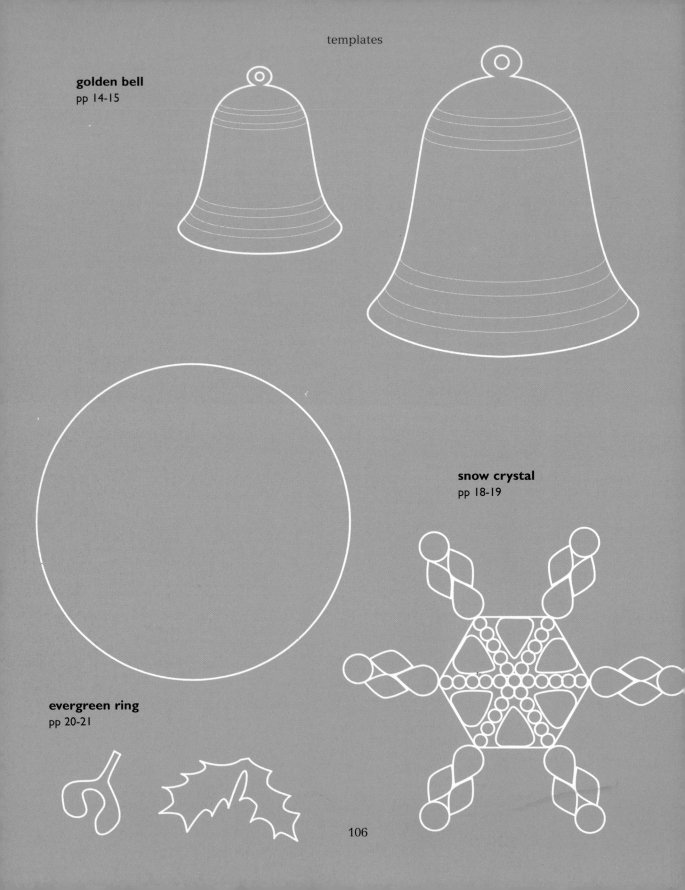

golden bell
pp 14-15

snow crystal
pp 18-19

evergreen ring
pp 20-21

106

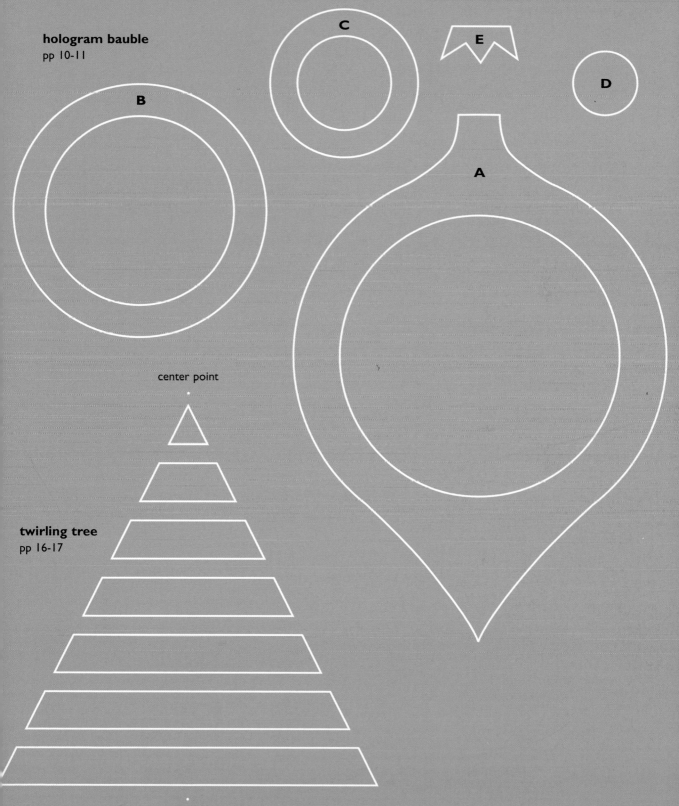

hologram bauble
pp 10-11

twirling tree
pp 16-17

C

E

D

B

A

center point

center point

star of david
pp 28-29

spinning teddy
pp 70-71

love birds
pp 56-57

108

moon and stars
pp 30-31

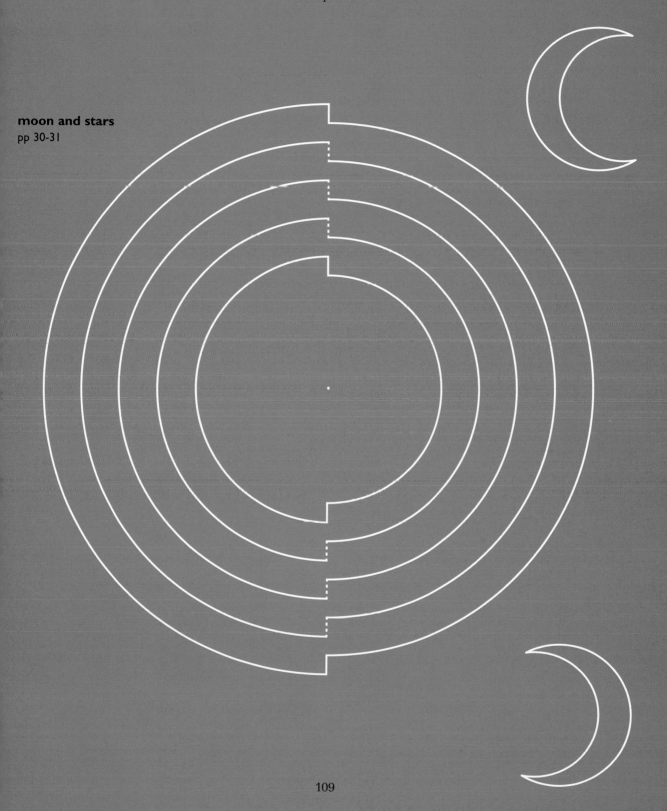

easter egg
pp 32-33

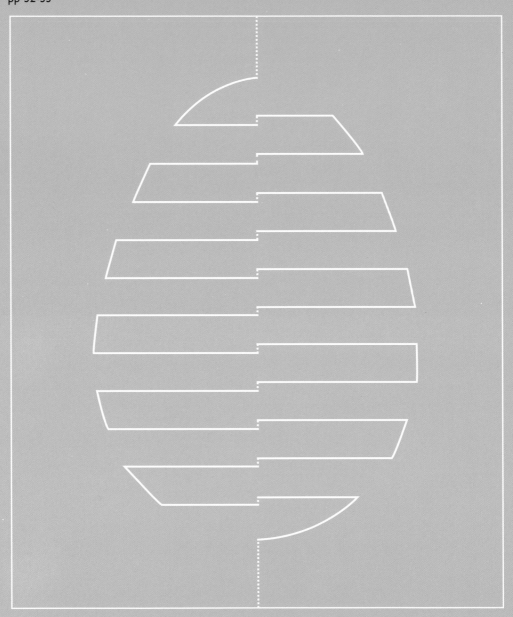

silver fish
pp 34-35

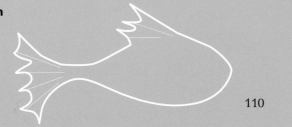

110

farewell wishes
pp 38-39

lucky horseshoe
pp 40-41

new home
pp 44-45

candle glow
pp 26–27

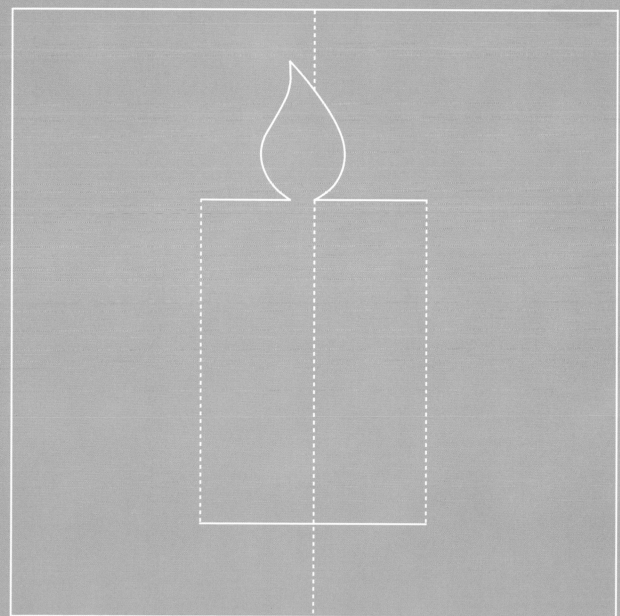

wedding bell
pp 58-59

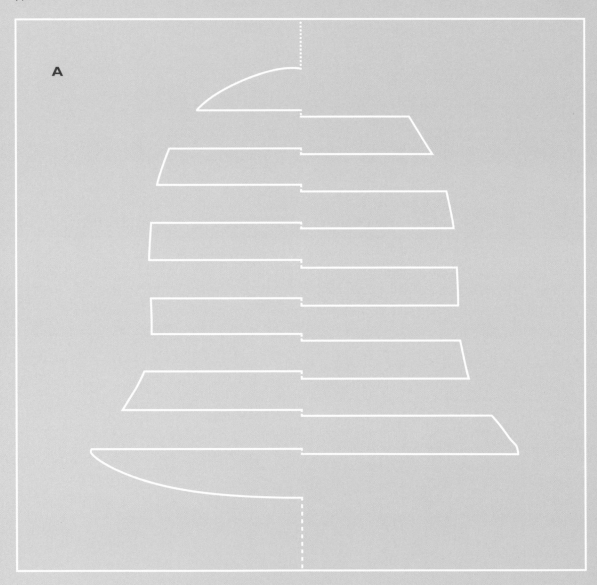

A

templates

wedding bell
pp 58-59

B

four-leaf clover
pp 42-43

blue marina
pp 64-65

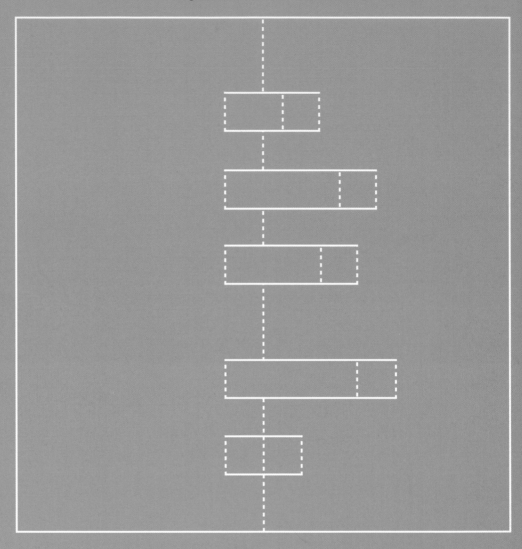

dancing snowmen
pp 22-23

birthday surprise
pp 66-67

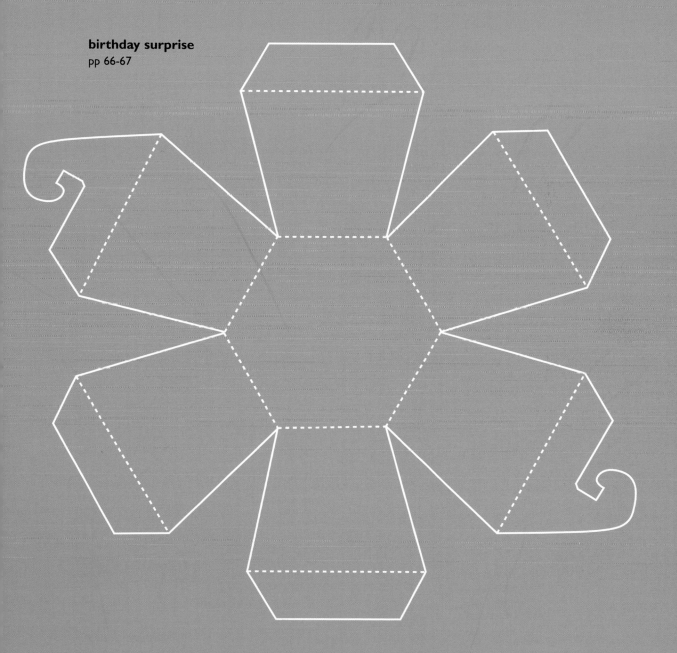

center point

soft hearted
pp 50-51

center point

rustic sunflower
pp 68-69

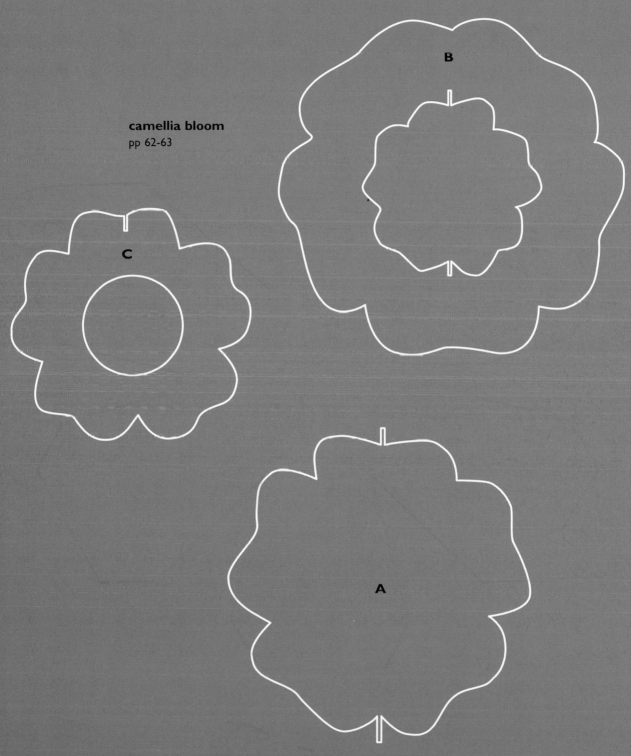

camellia bloom
pp 62-63

B

C

A

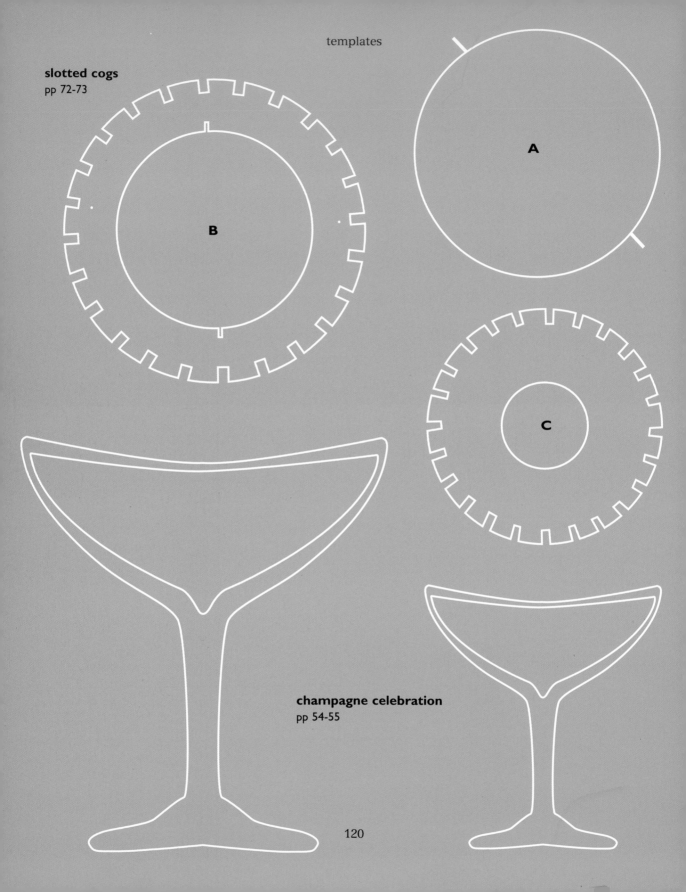

slotted cogs
pp 72-73

A

B

C

champagne celebration
pp 54-55

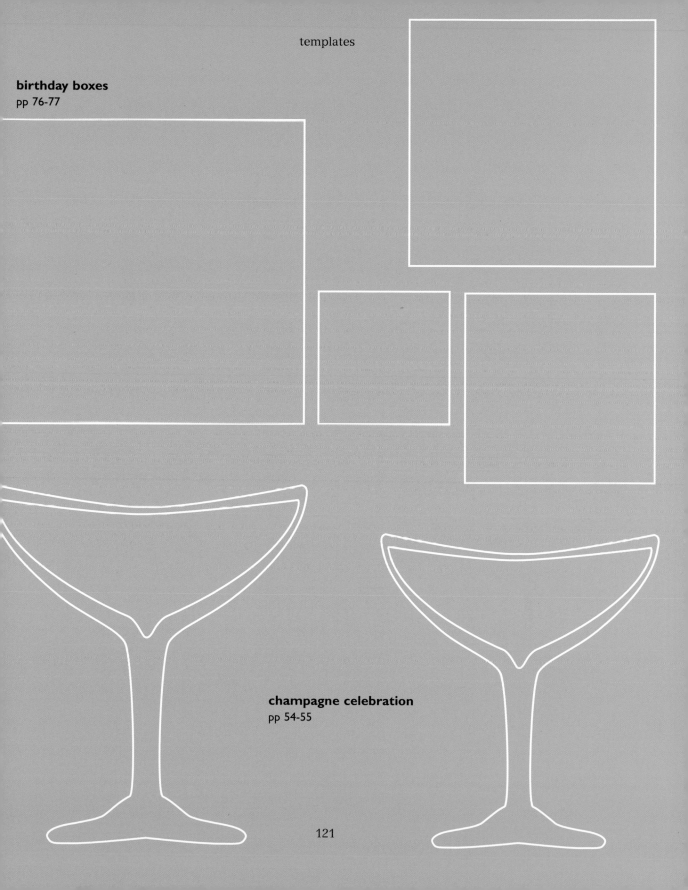

birthday boxes
pp 76-77

champagne celebration
pp 54-55

envelopes

A well-matched envelope adds a real polish to your handmade card, but bear post office guidance in mind if you are sending your greeting.

Choose the best proportioned template for your card from the selection on p123–125, and photocopy, enlarging by 200% so that your card will fit easily on the central rectangle or square. Cut out the template, transfer onto a piece of paper that matches your card, and cut out the envelope.

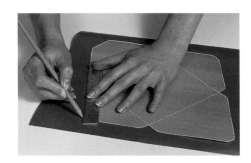

Using the dotted lines on the template as a guide, fold along the sides of the central rectangle or square to form the flaps of the envelope. Open out the top and bottom flaps again, in readiness for gluing in step 3. If you wish to add a decorative border to the front of the envelope, do so before you glue the flaps.

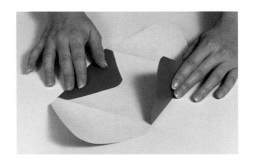

Glue the lower edges of the two side flaps sparingly, taking great care that the glue does not ooze onto the reverse of the front of the envelope. Fold in the bottom snub-nosed flap onto the glued edges. Allow to dry before inserting the card. Finally, seal with more glue, adhesive tape, or decorative stickers.

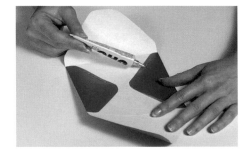

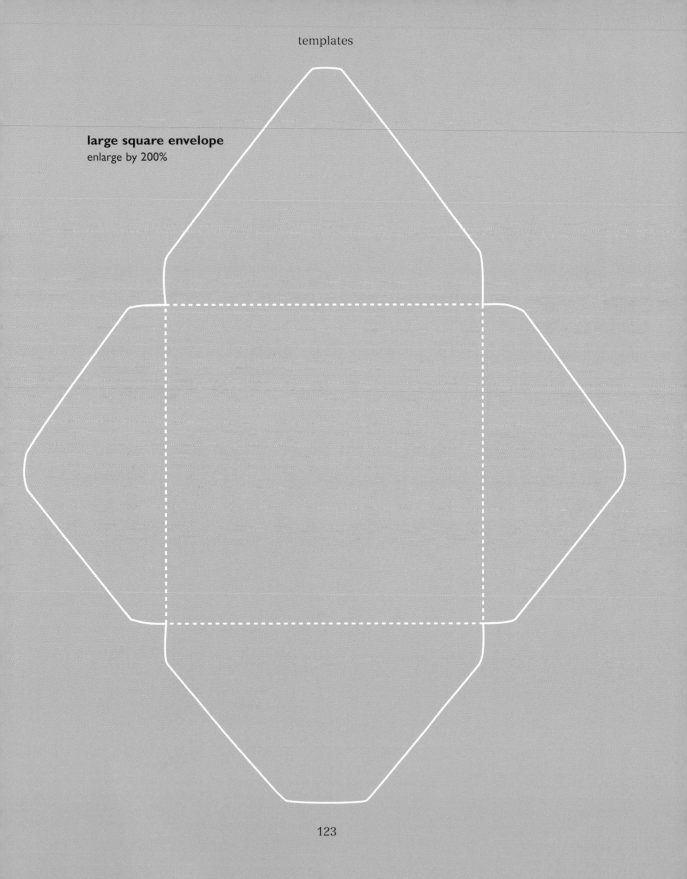

large square envelope
enlarge by 200%

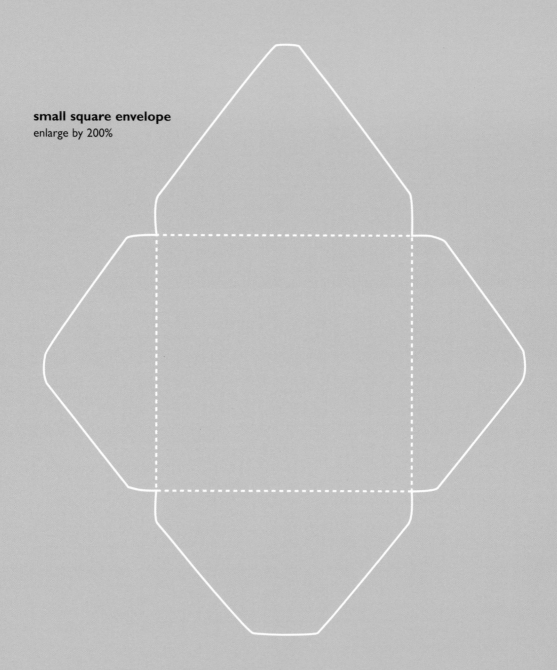

small square envelope
enlarge by 200%

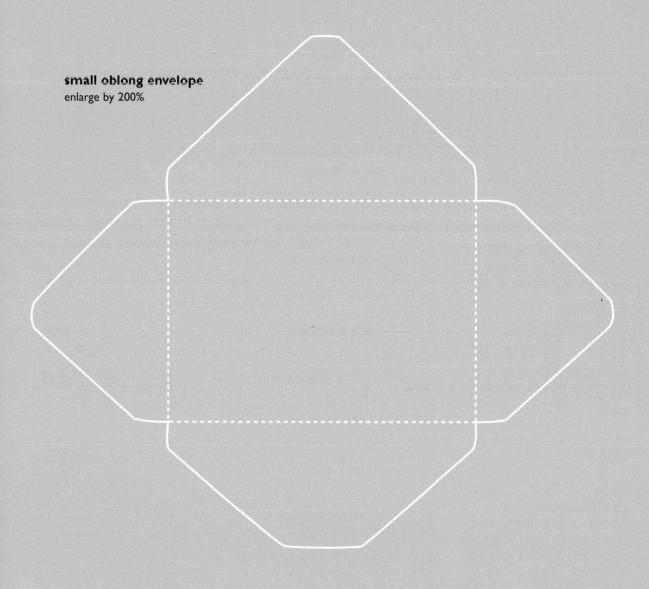

small oblong envelope
enlarge by 200%

large oblong envelope
enlarge by 200%

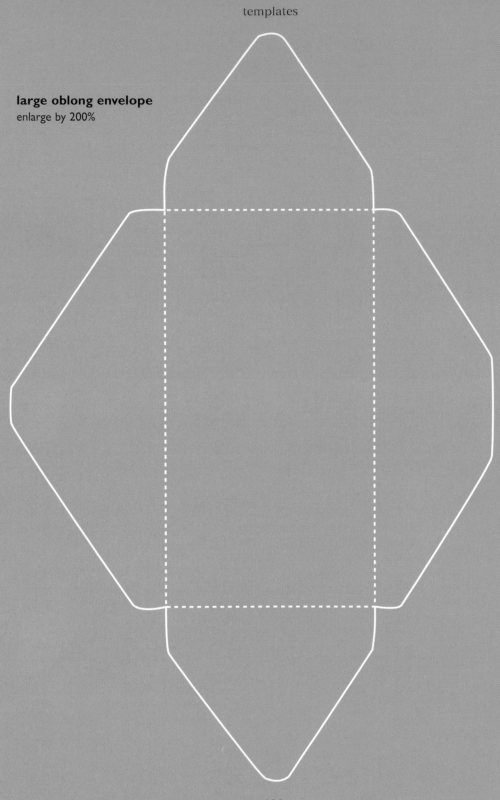

index